'Art and Fear' and 'Art as Far as the Eye Can See'

Some titles are not available in North America.

'Art and Fear' and 'Art as Far as the Eye Can See'

Paul Virilio

Translated by Julie Rose

BLOOMSBURY ACADEMIC
LONDON · NEW YORK · OXFORD · NEW DELHI · SYDNEY

BLOOMSBURY ACADEMIC
Bloomsbury Publishing Plc
50 Bedford Square, London, WC1B 3DP, UK
1385 Broadway, New York, NY 10018, USA

BLOOMSBURY, BLOOMSBURY ACADEMIC and the Diana logo
are trademarks of Bloomsbury Publishing Plc

Art and Fear first published 2000 in France as *La Procédure Silence*
Copyright © Editions Galilée, 2015
English translation first published 2003 by Continuum
English translation copyright © Julie Rose, 2003
Introduction © John Armitage, 2003

Art as Far as the Eye Can See first published 2005 in France as *L'art a perte de vue*
Copyright © Editions Galilée, 2015
English edition first published 2009 by Berg
Paperback edition published 2010
English translation copyright © Berg Publishers, 2007, 2010

This Bloomsbury Revelations edition published 2020

This work is published with the support of the French Ministry of Culture – Centre National du Livre.

ʈi institut français

This book is supported by the French Ministry for Foreign Affairs as part of the Burgess Programme
headed for the French Embassy in London by the Institut Français du Royaume-Uni.

The Publishers wish to record their thanks to the French Ministry of Culture for a grant towards the
cost of translation.

Series design by Clare Turner
Cover image © Pixhall / Alamy Stock Photo

A catalogue record for this book is available from the British Library.

A catalog record for this book is available from the Library of Congress.

ISBN: PB: 978-1-4742-4410-7

Series: Bloomsbury Revelations

Typeset by Newgen Knowledge Works (P) Ltd., Chennai, India

To find out more about our authors and books visit
www.bloomsbury.com and sign up for our newsletters.

Contents

PART ONE
ART AND FEAR

TRANSLATOR'S PREFACE

Immediately after September 11 – an event that did not take him by surprise – people who had always dismissed Virilio as a pessimist started plaguing him for interviews. When I spoke to him at the time in Paris, where a plan to blow up the American Embassy had just been dismantled, he said: 'There are no pessimists; there are only realists and liars.'

A realist to the core, Virilio will always be the first to make certain connections. For example, others before this have attacked modern art's dance of the seven veils, the stripping of art's subjects and materials down to the bare bones of an insubstantial representation. But it is Virilio who names the process violence, pinpoints the fear that subtends it and makes the connection between this violence and the violence of the battlefields of the Great War, for example, when the first abstract canvases appeared and the human figure was literally and figuratively blasted to bits; or the horrific return to a literal figurative, with Dr von Hagens' real human corpses – of unknown origin – filled with plastic preservative and exposed as anatomical art, at the very moment the scientific community is baying for human embryos to 'engineer'. No one else has traced this twin genealogy of art and science that has had so much to do with the 'routine horrors' of the last hundred years.

Some people react badly not only to Virilio's home truths, but to the gusto with which they are uttered. When *La Procédure silence* came out in France at the end of 2000, Virilio received threats of violence against his person. He fielded questions on talk-back radio from 'art lovers' who showered him with righteous spite. That flak alone constitutes proof if proof were needed of the pertinence of what he has to say here about contemporary art and terrorism, silencing and noise. Virilio does not mince words, whether in conversation or essay and these papers are both. So it is impossible not to take a stand, whatever that might be.

One pivotal dichotomy in what follows needs explaining here. You will see I use 'pitiful' and 'pitiless' throughout, as Virilio does, and have kept those terms even where a more sympathetic English word might seem called for – because it is not. The opposition between being full of pity – pitiful – and being absolutely without it is crucial to the argument. And being full

of pity can also have the pejorative sense of being pathetic, somewhat con-
temptible, as opposed to its positive sense of compassionate. So, apologies to
Bob Dylan fans when he pops up as 'a pitiful musician par excellence'. By the
time you come to that phrase, you know that 'pitiful' means 'human' in our
fond expression, as well as, yes, 'pathetic'. The shorthand is true to form and
hopefully works in the English, as in the French, to cover a lot of territory
in just a few strokes.

Julie Rose
2002

ART AND FEAR: AN INTRODUCTION

Paul Virilio is now recognized for his theorizing of aesthetics and politics throughout the English-speaking world. The translation and publication of *Art and Fear* adds considerably to his discussions of contemporary art and the politics of human silence. These are both subjects that Virilio is increasingly anxious about. In diverse respects Virilio feels alienated from the 'pitiless' way in which twenty-first-century artists, unlike twentieth-century modern artists, seem incapable either of understanding the full horror of human violence or remaining silent. Greatly interested in every kind of creative departure, in these two essays on 'A Pitiless Art' and 'Silence on Trial' Virilio broadens his earlier deliberations on the 'aesthetics of disappearance'.[1] In particular, he is interested in re-evaluating twentieth-century theories of modern art and duration, the spoken word and the right to stay silent in an era that is increasingly shaped by the shrill sonority of contemporary art.

Even so, Virilio's questioning of twentieth-century theories of modern art, the removal of silence and the contemporary art that has issued from such premises and practices cannot be understood as a post-structuralist rejection of humanism or the real human body. Rather, it must be interpreted as the search for a humanism that can face up to the contempt shown towards the body in the time of what Virilio labels the 'sonorization' (the artistic production of resonant and noisy sound-scapes) of all visual and virtual representations. Virilio elucidated this recently concerning Orlan and Stelarc, both world-renowned multimedia body artists. Speaking in an interview entitled 'Hyper-violence and Hypersexuality', Virilio castigates these leading members of the contemporary 'multimedia academy' while discussing his increasing consternation before their pitiless academic art that also involves the condemnation of a silence that has become a kind of 'mutism'.[2] As he put it, anti-human body art 'contributes to the way in which the real body, and its real presence, are menaced by various kinds of virtual presence'.[3]

As an elder French theorist born in Paris in 1932, Virilio is indebted to his experience of the Second World War. Resembling the Viennese Actionists of the 1960s he cannot detach his thought from the event of Auschwitz. Virilio

is then continually responsive to the most frightening and extremely horrific features of our epoch. It was, though, the Second World War and, in particular, the tragedy of the Nazi concentration and extermination camps that educated Virilio about the depths of human violence. Or, more precisely, the catastrophe of the Nazi death camps encouraged him to respect the human body and its capacity for silence. In different ways, then, Virilio is forging and transforming our understanding of the ethical dilemmas associated with silence and the subsequent aesthetic conflicts linked to the sonorization of the audio-visual within the sphere of contemporary art.

Through offering his Christian assistance to the homeless of post-Second World War Paris, while simultaneously producing theoretical critiques of the dehumanizing characteristics of total war, Virilio gradually discovered his humanism. Crucial to this discovery is an assessment of the aesthetics and ethics of human perception, an assessment that Virilio began to piece together. Yet no simple appeasement with the nineteenth-century situation of industrialized modernization was possible. This is because, for Virilio, it was through the carnage of the First and Second World Wars that modern art, from German Expressionism and Dada to Italian Futurism, French Surrealism and American Abstract Expressionism, had developed first a reaction to alienation and second a taste for anti-human cruelty.

'To write poetry after Auschwitz is barbaric', wrote Theodor Adorno, a statement that Virilio believes even Adorno would now have to acknowledge as an underestimation, given the increasing pace of artistic desperation, the catastrophes of modernity and the crisis in modern art.[4] Spellbound by human violence, Virilio considers that contemporary artists have abandoned their function of continually reassessing the creative practices and sensibilities, imagination and cultural meaning of the advanced societies. In contrast to Nietzsche, Sartre or Camus, Virilio claims that he is anxious to study the varieties of life and the contemporary art of the crisis of meaning that nineteenth- and twentieth-century artists have shaped and the genocide that homicidal rulers have in reality committed. Connecting a multiplicity of artistic, philosophical and political resources, Virilio is crucially engrossed in examining the revolution that contemporary art is presently undertaking through its espousal of terroristic aesthetic procedures and the premeditated termination of the enunciation of silence.

The assaults on signs and silence that Virilio observes in contemporary art were already deadly in intent by the 1950s. For him it is not a matter of witnessing a real murder but more exactly the murder of signs of artistic pity

in the name of freedom of artistic representation. Contemplating the unwritten and nightmarish hallucinations of nineteenth- and twentieth -century art and terror, Virilio is apprehensive not to overlook that this was a historical epoch that simultaneously administered the implosion of the avant-garde and the monochromatic and the explosion of nuclear weapons in glorious Technicolor.

Virilio thinks, for example, that the nihilistic sensibilities of nineteenth-century Russian intellectuals cannot be divorced from the grave disarray to be found today in the advanced democracies. Furthermore, twentieth-century art, through its expectation of the contemporary politics of hate, has added to the downfall of pitiful art and to the rise of a pitiless art that privileges hot colours over cold and the sonorization of all earlier silent imagery. Virilio is also critical of the contemporary world of revulsion represented in New German Painting and managed by an art market captivated by annihilation. Determining the sensitivities of today's artists in the manner of German Expressionism, contemporary art disdains the silent pity of nineteenth- and twentieth-century images of the bloodshed of battle. In its place, according to Virilio, as we shall see in the next section, pitiless art embraces seductive TV images of carnage.

A pitiless art

In explaining the aesthetics of disappearance in modern representative art, Virilio characterized its theories as abstract, being concerned to acknowledge that it is vanishing.[5] Today, describing 'a pitiless art', he illustrates its premises as 'presentative', a recognition that representative art is finished. But where do Virilio's rather extraordinary accounts develop? What do such assertions denote? In effect, he is voicing a doubt previously felt by him in *The Art of the Motor* and *The Information Bomb*: that, under the influence of new information and communications technologies, democratic institutions are disappearing as the key locations where political representation operates.[6] Virilio writes of the emergence of public opinion and the appearance of a 'virtual' or 'multimedia democracy' that is not just obliterating democracy but also the senses of the human body, with the growth of hyperviolence and an excessively and peculiarly sexless pornography. He argues that instead of producing a merciless art of presentation, with its live TV images of genuine torment and aggression, its wretchedness, self-destruction, disfigurement, extinction and abhorrence, contemporary artists should

reclaim the evacuated space of the art of representation, the space of symbolic yet crucially sympathetic images of violence.

In considering the art of representation, Virilio is seeking a debate over the status of negationism in art. The associations between contemporary aesthetics and modern ethics also permit him to introduce the problem of compassion. For Virilio, this entrusts the aesthetics of fear with the task of detecting a type of immediacy and a system of representation totally dissimilar to presentational art. This indicates that contemporary artists ought not to maintain their concentration on a chaotic and heartless form of perception. The artistic suppression of sympathy, prejudiced by the attack of medical science on the body and its subsequent presentation, presupposes that the dead are of concern only when either violating some existing prohibition or offering themselves up as images of torture. Indifferent to the sensitive attitude to the body, presentational art opens up aesthetic forms that for Virilio are dissimilar to those of the Viennese Actionists, even if something of the Actionists' self-sacrificial and violent artistic practices endures. Taking the poetic truth of brutal reality out of the loop, today's lethal presentational art of scientific voyeurism is powerless to express the actual extent of human cruelty.

Yet, as Virilio proposes, the aesthetics of disappearance also offers a mask to those artists who refuse to recognize its transgressions. He justifies this vital conception by way of his contention that the depravity of contemporary art commenced in advertising before transferring to the everyday craving for murder that also brings into being the totalitarianism of unquestioning belief. As a result, contemporary art does not check mass mediated nihilism but rather assumes that the representational techniques of the aesthetics of disappearance will persist in further debasing our entire 'hyper-modern' or 'excessive' idea of humanity.[7] For his part, Virilio refuses to tolerate an aesthetics that implies the disappearance of every type of art except presentational art. In insisting on its deceptive closeness, Virilio is objecting to a presentational art that seeks out the total destruction of careful viewer contemplation. Challenging the theories of the Canadian media mystic Marshall McLuhan, and particularly McLuhan's concept of an 'absolute present', Virilio advances the idea that it is impossible to eradicate the comparative and the momentary in questions concerning the analogical experience of events. In other words, Virilio has no plans to become a theorist who surrenders to the lure of a life lived in the immediacy of mass mediated despair.

Hence, when Virilio considers the aesthetics of disappearance, he assumes that the responsibility of artists is to recover rather than discard

the material that is absent and to bring to light those secret codes that hide from view inside the silent circuits of digital and genetic technologies. It is through the idea of the demise of a kind of transitory imaginary that Virilio expounds his perception of the nihilism of current technology. He judges, for example, that since genetics has now become culture, artists also have started to converse in the idiom of 'counter nature', but for the benefit of the performative goals of eugenics. In so doing, Virilio argues that artists critically fail to appreciate what ethical concerns are at risk in the genetic factories of fear. Virilio meets such ethical dilemmas head-on when he describes his aesthetics of disappearance as a conception that can be characterized as 'pure nature'. This is owing to the fact that, in his view, and especially following the transformations literally taking shape in genetics, culture and science are now free of almost all human scruples. Given that aesthetics and ethics are ailing, Virilio advises that artists show mercy on both, while combating the globalization of the techno-scientific propaganda of cloning, the new science of human disappearance.

For him, no ethical forces or even the aesthetics of disappearance can rationalize a technoscience that has become theatre after the time of total war or in the present period where the will to exterminate reigns supreme. Such occurrences, contends Virilio, necessitate the denunciation of the pitilessness of a contemporary art that combines with eugenics and cloning while inconsiderately and self-consciously connecting to the repulsion of the Nazis' experimentation first on animals and then on humans. The significance of these episodes is established through the fact that they serve to corroborate that Nazi criteria are at the present time the foundation on which scientists and artists seek to establish a new humanity. As Virilio maintains, the scientific formation of humans is today a certainty whose meanings are technologically determined, calling to mind not the natural labour of procreation but the artificial work of scientific creation in which the development of eugenics without frontiers is well under way. Intensely attentive to post-human developments, Virilio has nonetheless realized that any cultural politics that seeks out restrictions to a freedom of aesthetic representation devoid of frontiers confronts a difficult task. As he explains it in 'A Pitiless Art', after violating the 'taboos of suffocating bourgeois culture, we are now supposed to *break the being*, the unicity of humankind'. In Virilio's terms, then, and owing to the 'impending explosion of a genetic bomb' of scientific excess, the 'counter culture' of nature 'will be to biology what the atomic bomb was to physics'.

Virilio is also anxious to determine how extreme artists and scientists are willing to think and act before making an objection, for example, to 'snuff' literature. This is because for him the impulse to torture imagines a readiness to ruin the evaluation of the art lover, to 'derealize' contemporary art, theatre and dance. Virilio thinks that today's artists are no longer able to ascertain the genuine character of flawed and shattered bodies or the degree of self-hatred at work in their creations. In his view, snuff literature is the gateway to snuff videos and snuff dance, given that pity is excluded from the outset. Virilio is, however, unconcerned with instituting an alternative declaration to that of Adorno's concerning the writing of poetry that will stand up to the barbarism moving within the advanced societies after Auschwitz. To be more precise, he is apprehensive to say the least about a freedom of expression that features a call to murder. Consequently, Virilio questions a political correctness that presupposes a terroristic, suicidal and self-mutilating theory of art. Making links between contemporary art and genetically modified seeds bearing the label 'terminator', he is trying to find an image of pitiful art that exists outside of the conditions of bio- or 'necro-technology'. Refusing technoscientific 'success' at any price, Virilio insists on a cultural critique of scientific experiment, technological inhumanity and deformity.

Such moral and artistic refusals Virilio understands as a thought-provoking enquiry into a freedom of scientific expression that is at present as limitless as freedom of artistic expression. He declares his unqualified opposition to the appearance of a 'transgenic art' that is tolerable neither within its own self-designation nor as the starting point for a contemplative relationship between the species. Exploring the hypermodern 'cult of performance' in a genuine human race directed by the global magnates of sport, finance and the media, Virilio is adamant on the subject of his questioning of a biologically contrived 'super-humanity' lacking adequate ethical procedures or limitations. To be sure, he wants to turn his back on the fashionable scientific and artistic idea of the human body as a technologically assisted survival unit that has outlasted its usefulness. Rejecting what Arendt identified as the 'banality of evil' at work in Nazism and more lately in Pol Pot's Cambodia and elsewhere, Virilio concludes 'A Pitiless Art' with a plea to condemn the transgressions of contemporary art.[8] In 'Silence on Trial', though, he challenges whether all that stays silent is judged to consent, to allow without a murmur of complaint the contemporary conditions of audio-visual overload.

Silence on trial

In this essay Virilio is for the most part involved with exposing a silence that has lost its ability to 'speak', with a mutism that takes the form of a censorship of silence in an age awash with the obscenity of noise. Unrestricted 'Son et Lumiere' events and 'live' art exhibitions, for instance, currently flood many social and cultural spaces. Virilio recognizes such occasions as illustrations of the disappearance of representation and the motorized regime of speed in contemporary art that confirms the substitution of the aesthetics of appearance by the aesthetics of disappearance. Assuming a historical perspective, he points to the previously neglected significance of the appearance and imposition of talking pictures or 'talkies' in the 1920s. In fact, in Virilio's opinion, it was in this period that citizens who indicated silence as a mode of articulation were first judged to assent to the diminishing power of silent observation and the increasing supremacy of the audio-visual. In our day, however, the question according to Virilio is whether the work of art is to be considered an object that must be looked at or listened to. Or, alternatively, given the reduction of the position of the art lover to that of a component in the multimedia academy's cybernetic machine, whether the aesthetic and ethical silence of art can continue to be upheld.

Video and conceptual art have been increasingly important concepts of Virilio's work on the audio-visual torrent of the mass media and the digital contamination of the image ever since *The Art of the Motor* (1995). Nevertheless, it appears in 'Silence on Trial' that Virilio's interpretation of the new information and communications technologies of 'hyper-abstraction', such as the Internet, is shaping new forms of theoretical exploration that are necessitating an alternative approach to his previous writings on the speed of light. For in this essay Virilio also contemplates the speed of sound. As he describes it, the contemporary technique of painting with sound, lacking figures or images, first emerged in the late nineteenth and early twentieth centuries in the works of Wagner and Kandinsky, Schwitters, Mondrian and Moholy-Nagy. But, for Virilio, present-day sound art obliterates the character of visual art while concurrently advancing the communication practices of the global advertising industry, which have assaulted the art world to such a degree that it is at present the central dogma of the multimedia academy. People today, for example, have to endure the pressure of the 'ambient murmuring' of incessant muzak at the art gallery, at work or at the shopping centre. Furthermore, their silence on such matters is, in

Virilio's terms, connected with the closing phase of the aesthetics of disappearance that is also the gateway to a new 'aesthetics of absence', an absence where the silence of the visible is abolished by the sound of audio-visual multimedia. However, as Virilio makes clear, in struggling against the aesthetics of absence in the name of the silence of the visible, it is important not to overemphasize the significance of the visual cinematic image in particular as a method of examining the power of sound. From his perspective, this is due to the fact that cinematic images saturate human consciousness and are more damaging than often recognized. Virilio places his hopes in the 'accident of the visible' and the annihilation of the audio-visual by a politics of silence. Dating the contemporary crisis in the plastic arts from the invention of the talkies, he insists that this is the basis of the resulting condemnation of human deafness and the marketing of sound that has given rise to the 'trauma of the ear'. Equally significantly, Virilio is especially sceptical of the insertion of speech into the image, owing to the fact that the art lover rapidly becomes a casualty of the speed of sound and a prisoner of the noise of the visible. It is also important to keep in mind that for him the arts are presently transfixed by a will to noise, a phenomenon whose objective is the purging of silence. For these reasons, as Virilio understands it, the turmoil in contemporary visual art is not the consequence of the development of photography or the cinema but the outcome of the creation of the talkies. Such a declaration in addition relates to his questioning of the waning of oral traditions that unsurprisingly for Virilio entails the ever 'telepresent' talking image and the ever fainter presence of silent reality. To say nothing, declares Virilio, is not simply an act that leads to fear, to pitiless art and to pitiless times, but also to the domination of the immediacy of contemporary visual art by the sonority of the audio-visual.

Implicated in Virilio's final thoughts about contemporary art's losing ground to sonority on account of its immediacy is his on-going resistance to the end of spontaneous reactions to works of art and the continuing imposition of the conditioned reflex action. Virilio's purpose at this juncture is to disrupt those graphic arts that unreservedly rely on the speed of sound. This strategy is typical of Virilio's 'pitiful' artistic stance and of his preceding radical cultural analyses. In *The Art of the Motor* and in 'Silence on Trial', for instance, Virilio rejects the screaming and streaming multimedia performances of the body artist Stelarc. As Virilio notes, it is of fundamental importance that the hyperviolence and hypersexuality that at present rule the screens of hypermodernity are challenged given that they are the supreme instigators of social insecurity and the crisis in figurative art. He

understands the art of the mass media consequently as the most perilous effort yet to manage the silent majority through a spurious voice conveyed through public opinion polls, corporate sponsorship and advertising. Virilio thus laments the eradication of the modern 'man of art' by hypermodern contemporary artists such as Stelarc. Such a loss to him is also an injury to all those who still yearn to speak even when they remain silent. Virilio is accordingly looking to uncover within the field of contemporary art the forces involved in the systematic termination of the silence of the visual and the gesture of the artist. By explaining in 'Silence on Trial' that such forces plan to extend the motorization of art while removing the sensations of the human subject, Virilio concludes that, for him at least, cybernetic art and politics have limits that do not include murder.

The aesthetics of Auschwitz

Commentators on Virilio's *Art and Fear* might claim that his powerful speculations on contemporary media are the conjectures of a critic of the art of technology who has lost hope in the ability of modernism and hypermodernism to effectively face up to rising hyperviolence and hypersexuality. His works and interviews as a rule are, however, very much concerned with circumventing the dangers of an indiscriminate aesthetic pessimism. Yet it does appear in 'A Pitiless Art' and 'Silence on Trial' as if he is at times perhaps excessively disparaging of the trends and theories associated with contemporary art and film, politics and the acceleration of the mass media. In condemning pitiless art and the recent ordeal experienced by those seeking a right to silence without implied assent, he is possibly rather too cautious with regard to the practices of contemporary art. As in the case of the body artist Stelarc, Virilio's criticism of his work tends to overlook the remarkable and revolutionary questioning of the conventional principles of the functioning of the human body that Stelarc's medical operations and technological performances signify. For Virilio, however, the humiliation of the art lover through the imposition of pitiless images and ear-splitting sound systems in the art gallery and elsewhere is not so much the beginning of an aesthetic debate as the beginning of the end of humanity.

In the same way, the thinking behind Virilio's recent writings on the idea of a contemporary multimedia academy only adds to the feeling that he increasingly proposes a type of criticism that is antagonistic towards academia generally. One difficulty with this sort of strategy is that in order

to oppose accepted theoretical dialogues on art and politics Virilio is obliged to ignore or to engage with them and in both instances thereby draw attention to the fact that his work cannot sustain itself without such discourses. Virilio's dilemma, of course, then develops into that of both being censured for his lack of familiarity with the contemporary aesthetic and political discussions that he disapproves of and for trying to place his work outside of such deliberations. In other words, Virilio is from time to time in danger of staging a debate with only himself in attendance. Forever on the look out for innovative body artists and other multimedia projects that expose the hypermodern condition, Virilio is perhaps wont to unfairly accuse them of surrendering to a style of uncritical multimedia academicism. In so doing he can occasionally be read as if he is unaware that a body artist like Stelarc also criticizes multimedia academicism as well as traditional conceptions of identity.

Stelarc's theoretical and applied technological revolutions in the field of contemporary art also function to transform questions concerning art's power of effect and inadvertently assist Virilio in conceiving of pitiless art and its deafening manifestation as crucial characteristics of the present hypermodern order. He is, in short, developing a stimulating mode of theorizing in these essays, which moves away from that typically found in contemporary art. What is absolutely vital for Virilio is the technological means by which contemporary art has abandoned its passion and sexual force. Conversely, it is important to stress that he is undoubtedly concerned not to characterize contemporary art in opposition to theory or aesthetic fervour, but to distinguish it as a pitiless and emotionless reaction to the disastrous circumstances of hypermodernity. As a result of such heartfelt aesthetic declarations, Virilio is quick to single out the hypersexuality of contemporary pornography as the most recent source of pitiless representations and sadistic ideas.

Given that contemporary artists and specialists in pornography have twisted pitilessness and noise into the rallying call of a totally destructive and increasingly non-representational regime, it is hardly surprising that Virilio senses that he must dissociate his work from what might be called the 'aesthetics of Auschwitz'. Here, Virilio is in fact paying attention to the reproduction and globalization of the aesthetics of Auschwitz in the present day. He thus not only refuses the collective delusion that Auschwitz was a singular historical event but also Adorno's assertion that to write poetry after it is barbaric. Virilio wants to recognize that in video and film, TV and on the Internet, Auschwitz inhabits us all as a fundamental if often repressed

component of contemporary processes of cultural globalization. Today, as a result, art, according to Virilio, confronts the predicament first identified by Walter Benjamin, that is, of imagining that barbarism and warfare will 'supply the artistic gratification of a sense perception that has been changed by technology'. In jeopardy of preoccupying itself with virtualized self-absorption, contemporary art, Virilio argues, as well as humanity, has attained such a level of 'self-alienation' that it can now 'experience its own destruction as an aesthetic pleasure of the first order'.[9]

As Virilio interprets it in *Art and Fear*, the outcome of contemporary aesthetic and political theories and practices is that the viewer of art has been converted into a casualty of a pitiless aesthetics bent on the sonorization of everything. In 'A Pitiless Art' and 'Silence on Trial', however, it is not so much Virilio's aesthetics of disappearance that takes centre stage but rather his reconsideration of twentieth-century art and especially its associations with the ruling audio-visual regime of contemporary art. Rejection of the human body or its virtualization, declares Virilio, are the only alternatives presented to the art lover by the multimedia academy led by body artists such as Orlan and Stelarc. For him, these and other artists and the multimedia events they perform disclose their anti-humanism and lack of respect for the body. Virilio condemns pitiless art and the destruction of silence as a consequence of his belief that the mutism intrinsic to contemporary body art shows the way to the terrorization of the real body by the virtual body. Virilio's words of warning to contemporary artists are that to stop thinking about the Second World War and Auschwitz is to forget the reality of the horror of war and the violence of extermination. It is to ignore the responsibility to value the body and its alternating attachments to silence and noise.

In evoking this responsibility, Virilio explains that he employs his Christian humanist critique of war, alienation and cruelty in an artistic and political sense, perhaps as an *aide-mémoire* of a further precise obligation to poetry or as an awareness of the aesthetics of Auschwitz. Hypermodern art is for Virilio a manifestation of a contemporary aesthetics that aspires to celebrate Nietzschean violence while discounting a crisis of meaning that is so profound that it is fast becoming indistinguishable from what he describes in 'A Pitiless Art' as 'the call to murder and torture'. Remember, asks Virilio, the 'media of hate in the ex-Yugoslavia of Slobodan Milosovic' or the '"Thousand Hills Radio" of the Great Lakes region of Africa calling Rwandans to inter-ethnic genocide?' Faced with such 'expressionist events', he answers, 'surely we can see what comes next, looming over us as it is: an *officially terrorist art* preaching suicide and self-mutilation – thereby

extending the current infatuation with scarring and piercing'. Contemporary art is then the expression of all those artists who take for granted that today's transformation of the field of aesthetics into a kind of terroristic performance also implies the elimination of silence. As a constant critic of the art of technology and the current attack on representation, Virilio is intensely uneasy about the development of pitiless art. He challenges its claim to a freedom of expression that demands the implosion of aesthetics, the explosion of dread and the unleashing of a worldwide art of nihilism and a politics of hate. Virilio thus looks to reclaim a poignant or pitiful art and the politics of silence from an art world enchanted by its own extinction because to refuse pity is to accept the continuation of war. But, more than this, in the pages that follow, he seeks to go beyond the gates of pitiless art and the prosecution of silence in order to explore the aesthetics of Auschwitz, the source of all our contemporary art and fears.

<div align="right">

John Armitage
2002

</div>

A PITILESS ART

This pitiless century, the twentieth.

Albert Camus

This evening we are not going to talk about piety or impiety but about pity, the pitiful or pitiless nature of 'contemporary art'. So we will not be talking about profane art versus sacred art but we may well tackle the profanation of forms and bodies over the course of the twentieth century. For these days when people get down to debate the relevance or awfulness of contemporary art, they generally forget to ask one vital question: *Contemporary art, sure, but contemporary with what?*

In an unpublished interview with François Rouan, Jacqueline Lichtenstein recently recounted her experience:

> When I visited the Museum at AUSCHWITZ, I stood in front of the display cases. What I saw there were images from contemporary art and I found that absolutely terrifying. Looking at the exhibits of suitcases, prosthetics, children's toys, I didn't feel frightened. I didn't collapse. I wasn't completely overcome the way I had been walking around the camp. No. *In the Museum, I suddenly had the impression I was in a museum of contemporary art.* I took the train back, telling myself that they had won! They had won since they'd produced forms of perception that are all of a piece with the mode of destruction they made their own.[1]

What we will be asking this evening will thus take up where Jacqueline Lichtenstein left off: did the Nazi terror lose the war but, in the end, win the peace? This peace based on 'the balance of terror' not only between East and West but also between the forms and figures of an aesthetics of disappearance that would come to characterize the whole fin de siècle.

'*To humanize oneself is to universalize oneself from within*', they say.[2] Hasn't the universality of the extermination of bodies as well as of the environment, from AUSCHWITZ to CHERNOBYL, succeeded in *dehumanizing us from*

without by shattering our ethic and aesthetic bearings, our very perception of our surroundings?

At the dawn of industrial modernity, Baudelaire declared, '*I am the wound and the knife*.' How can we fail to see that, in the wake of the hecatomb of the Great War, when Braque and Otto Dix found themselves on opposite sides of the trenches in the mud of the Somme, modern art for its part forgot about the wound and concentrated on the knife – the bayonet – with the likes of Oskar Kokoschka, '*the scalpel-wielding artist*', before moving on through the German Expressionism of *Der Sturm* to the Viennese Actionism of Rudolf Schwarzkogler and his cohorts in the 1960s . . .

ART MAUDIT or Artist Maudit? What can you say, meanwhile, about the likes of Richard Hülsenbeck, one of the founding fathers of Dada, who told a Berlin audience in 1918, at a conference on the new trends in art, 'We were for the war. Dada today is still for war. Life should hurt. *There is not enough cruelty!*'[3] The rest is history. Twenty years later the '*Theatre of Cruelty*' would not be the one defined by Antonin Artaud but by Kafka, that prophet of doom of the metamorphosis engineered by the camps, the smashing to smithereens of humanism.

The slogan of the First Futurist Manifesto of 1909 – '*War is the world's only hygiene*' – led directly, though thirty years later this time, to the shower block of Auschwitz-Birkenau. And Breton's 'Surrealism', following hot on the heels of Dada, emerged fully armed from the fireworks of the Great War where common reality was suddenly transfigured by the magic of explosives and poison gases at Ypres and Verdun.

After that, what is left of Adorno's pompous pronouncement about *the impossibility of writing a poem* after AUSCHWITZ? Not much at the end of the day, for everything, or almost everything, kicked off at the turn of a pitiless and endlessly catastrophic century – from the TITANIC in 1912 to CHERNOBYL in 1986, via the crimes against humanity of HIROSHIMA and NAGASAKI, where one of the paintings in van Gogh's 'Starry Night' series went up in the nuclear blast.

Perhaps at this juncture it is worth remembering Paul Celan, the German poet who committed suicide in Paris in 1970, the same year that painter Mark Rothko did in New York . . . But why stop there in art's death roll, featuring as it does a constant suicide rate from the self-destruction of Vincent van Gogh, 'the man with the missing ear'?

You would think the drive to extinguish the suffocating culture of the bourgeoisie consisted specifically in exterminating oneself into the

bargain – the dubious bargain of the art market – thus giving ideas, for want of cultural ideals, to the great exterminators of the twentieth century!

Remember what Friedrich Nietzsche advised: '*Simplify your life: die!*' This extremist simplification, in which 'ornament is a crime',[4] has stayed with us throughout the history of the twentieth century, from the pointlessly repeated assault on the peaks of the Chemin des Dames in 1917 to the genocide perpetrated by the Khmer Rouge in Cambodia in the 1970s.

Avant-garde artists, like many political agitators, propagandists and demagogues, have long understood what TERRORISM would soon popularize: if you want a place in 'revolutionary history' there is nothing easier than provoking a riot, an assault on propriety, in the guise of art.

Short of committing a real crime by killing innocent passers-by with a bomb, the pitiless contemporary author of the twentieth century attacks symbols, the very meaning of a 'pitiful' art he assimilates to 'academicism'. Take Guy Debord, the French Situationist, as an example. In 1952, speaking about his *Film Without Images*, which mounted a defence of the Marquis de Sade, Debord claimed he wanted to kill the cinema '*because it was easier than killing a passer-by*'.[5]

A year later, in 1953, the SITUATIONISTS would not hesitate to extend this attack by trashing Charlie Chaplin, *pitiful actor par excellence*, vilifying him as a sentimental fraud, mastermind of misery, even a *proto-fascist*!

All this verbal delirium seems so oblivious of its own century and yet condescends to preach to the rest of the world in the name of freedom of artistic expression, even during a historical period that oversaw the setting up of the *balance of terror* along with the opening of the laboratories of a science that was gearing up to programme the end of the world – notably with the invention, in 1951, of thermonuclear weapons. It corresponds equally to *the auto-dissolution of the avant-gardes*, the end of the grand illusion of a *modernité savante*. You would think it was not so much *impressionism* that laid the foundations for the latter as the *nihilism* of the calamitous intelligentsia of nineteenth-century Russia, with men like Netchaïev decreeing that one had to 'forge full steam ahead into the mire' . . . And he was not talking about Turner's *Rain, Steam and Speed* (*The Great Western Railway*), the painting that paved the way for Monet's Impressionism.

Inseparable from the suicidal state of representative democracies, the art of the twentieth century has never ceased dangerously anticipating – or at least saluting from afar – the abomination of the desolation of modern times with their cardboard cut-out dictator that keeps popping up, whether it be Hitler or the 'Futurist' Mussolini, Stalin or Mao Zedong.

And so the emblematic figure emerges not so much of Marcel Duchamp as Charlie Chaplin or Bonnard, pitiful painter par excellence, as was Claude Monet, that miracle-worker of a *Rising Sun*, which is not quite the same as the one rising over the laboratories of LOS ALAMOS.

The new German painting, naturally, represents current sensibility in Germany and it really frightens me. The Ancients invented and represented the world of witches, but the world of Hate is a modern invention, the invention of Germany, spread out over the canvas. The demons of gothic pictures are child's play when it comes to the human, or, rather, inhuman, heads of a humanity bent on destruction. Furious, murderous, demoniacal heads – not in the style of the old masters but in completely modern manner: scientific, choking with poison gas. They would like to carve the Germans of tomorrow out of fresh meat . . .

So wrote the great art dealer René Gimpel, in his diary of 1925.[6] Gimpel was to disappear in the NEUENGAMME camp twenty years later on New Year's Day, 1945 . . . Thoroughly convinced of the lethal character of the works of Oskar Kokoschka, Emil Nolde or the sculptor Lehmbruck, Gimpel goes on to tell us that there never has been any such thing as old-master art or modern or contemporary art, but that the 'old master' shaped us, whereas the 'contemporary' artist shapes the perception of the next generation, to the point where no one is '*ahead of their time for they are their time, each and every day*'.[7]

How can we not subscribe to this statement of the bleeding obvious if we compare the fifteenth-century *PIETA OF AVIGNON* with the sixteenth-century *Issenheim Altarpiece* of Matthis Grünewald – both pitiful works – the 'expressionism' of the German master of the polyptych illustrating the atrocity of the battles and epidemics of his time in the manner of Jerome Bosch?

Today we could apply this observation about lack of anticipation to 'issues' such as the 'contaminated blood affair' in France and the (alleged) non-culpability of the politicians in charge at the time . . .

Without harking back to Jacques Callot or even Francisco de Goya and 'the miseries of war' of the Napoleonic era, we might remember what Picasso said when a German interrogated him in 1937 about his masterwork, *GUERNICA*: '*That's your doing, not mine!*'

If so-called old-master art remained *demonstrative* right up until the nineteenth century with Impressionism, the art of the twentieth century

became 'monstrative' in the sense that it is contemporary with the shattering effect of mass societies, subject as they are to the conditioning of opinion and MASS MEDIA propaganda – and this, with the same mounting extremism evident in terrorism or total war.

At the end of the millennium, what abstraction once tried to pull off is in fact being accomplished before our very eyes: the end of REPRESENTATIVE art and the substitution of a counter-culture, of a PRESENTATIVE art. A situation that reinforces the dreadful decline of representative democracy in favour of a democracy based on the rule of opinion, in anticipation of the imminent arrival of virtual democracy, some kind of 'direct democracy' or, more precisely, a presentative multimedia democracy based on automatic polling.

In the end, 'modern art' was able to glean what communications and telecommunications tools now accomplish on a daily basis: the mise en abyme of the body, of the figure, with the major attendant risk of systematic hyperviolence and a boom in pornographic high-frequency that has nothing to do with sexuality: We must put out the excess rather than the fire, as Heraclitus warned.

Today, with excess heaped on excess, desensitization to the shock of images and the meaninglessness of words has shattered the world stage. PITILESS, contemporary art is no longer improper. But it shows all the impropriety of profaners and torturers, all the arrogance of the executioner.

The intelligence of REPRESENTATION then gives way to the stunned mullet effect of a 'presence' that is not only weird, as in the days of Surrealism, but insulting to the mind. The whole process, moreover, implies that the 'image' suffices to give art its meaning and significance. At one extreme the artist, like the journalist, is redundant in the face-off between performer and viewer.

'Such a conception of information leads to a disturbing fascination with images filmed live, with scenes of violence and gruesome human interest stories', Ignacio Ramonet writes on the impact of television on the print media. 'This demand encourages the supply of fake documents, sundry reconstructions and conjuring tricks.'[8]

But surely we could say the same today of art when it comes down to it. Take the example of the NEW NEUROTIC REALISM of adman and collector Charles Saatchi, as revealed in the London (and New York) exhibition 'Sensation', with its fusion/confusion of the TABLOID and some sort of would-be avant-garde art. Yet the conformism of abjection is never more than a habit the twentieth century has enjoyed spreading round the globe.

Here, the brutality is no longer so much aimed at warning as at destroying, paving the way for the actual torturing of the viewer, the listener, which will not be long coming thanks to that cybernetic artefact: *the interactive feed-back of virtual reality.*

If the contemporary author is redundant – see Picasso on *Guernica* – and if the suicide rate has only kept accelerating in cultural circles to the point where it will soon be necessary to set up a WALL OF THE FEDERATED COMMUNE OF SUICIDES in museums (to match the wall of the federated communards of the Paris Commune in Pere La chaise cemetery), then make no mistake: the art lover's days are numbered!

This is how Rothko put it: 'I studied the figure. Only reluctantly did I realize it didn't correspond to my needs. *Using human representation, for me, meant mutilating it.*' Shot of all moral or emotional compromise, the painter seeks to move '*towards the elimination of all obstacles between the painter and the idea, between the idea and the onlooker*'.

This is the radiographic triumph of transparence, the way radiation of the real in architecture today goes hand in glove with the extermination of all intermediaries, of all that still resists revelation, pure and simple.

But this sudden OVEREXPOSURE of the work, as of those who look upon it, is accompanied by a violence that is not only 'symbolic', as before, but practical, since it affects the very intentionality of the painter: 'To those who find my paintings serene, I'd like to say that *I have trapped the most absolute violence in every square centimetre of their surface*', Mark Rothko confesses before proving the point by turning this repressed fury against himself on a certain day in February, 1970.

Thirty years on, how can we fail to feel the concentration of accumulated hate in every square metre of the 'uncivil cities' of this fin de siècle? Go one night and check out the basements or underground parking lots of suburban council estates, all that the clandestine RAVE PARTIES and BACKROOM brothels are only ever the *tourist trappings* of, so to speak!

After having 'only reluctantly' abandoned the figure on the pretext of not mutilating it, the American painter then chose to end this life himself as well by exercising the most nihilistic of freedoms of expression: that of SELF-DESTRUCTION.

If God died in the nineteenth century, according to Nietzsche, what is the bet that the victim of the twentieth century will not turn out to be the *creator*, the author, this heresy of the historical materialism of the century of machines?

But before we bid the Artist farewell, we should not forget for a moment that the words PITY and PIETY are consubstantial – something the members of the Holy Inquisition obviously overlooked . . . Let's not repeat their crimes, let's not become *negationists of art.*

To suffer with or to sympathize with? That is a question that concerns both ethics and aesthetics, as was clearly intuited by Géricault, the man who made his famous 'portraits of the insane' at La Salpêtrière Hospital in Paris over the winter of 1822 at the invitation of one Dr Georget, founder of 'social psychiatry'. Géricault's portraits were meant to serve as classificatory sets for the alienist's students and assistants.

Driven by a passion for immediacy, Géricault sought *to seize the moment –* whether of madness or death – live. Like the emergent press, he was especially keen on human interest stories such as the wreck of the *Medusa,* that TITANIC of the painting world . . .

The art of painting at the time was already busy trying to outdo mere REPRESENTATION by offering *the very presence of the event,* as instantaneous photography would do, followed by the PHOTO-FINISH and the first cinematographic newsreels of the Lumière brothers and, ultimately, the LIVE COVERAGE offered by CNN.

INTERACTIVITY was actually born in the nineteenth century – with the telegraph, certainly, but also and especially with clinical electricity, which involved planting electrodes on the faces of the human guinea pigs used in such 'medical art' as practised by Dr Duchenne de Boulogne. The recent Duchenne exhibition at the École des Beaux-Arts, Paris, aimed no less than to 'rehabilitate' Duchenne's work, though this La Salpêtrière Hospital photographer was no more than an 'expressionist of the passions' for whom his patients' faces were only ever laboratory material that enabled him to practise '*live anatomy*'.

Already in the eighteenth century just prior to the French Revolution, this confusion of *cold-bloodedness* with *a mode of perception* that allowed the doctor or surgeon to diagnose illness due to the ability to repress emotion – pity – had contaminated the artistic representations of 'naturalistic' painters and engravers. Jacques Agoty, for instance, as a painter and anatomist on the trail of 'the invisible truth of bodies', wavered between an engraver's burin and an autopsy scalpel in his work.

But the truly decisive step had to wait until much more recently, till 1998, with '*The World of Bodies*' exhibition at the the Mannheim Museum of Technology and Work (Landesmuseum fur Technik und Arbeit), where

close to 800,000 visitors rushed to contemplate 200 human corpses presented by Günther von Hagens.

The German anatomist actually has invented a process for preserving the dead and, in particular, for *sculpting* them, by plastination, thereby taking things a lot further than the mere embalming of mummies. Standing tall like statues of antiquity, the flayed cadavers either brandished their skins like trophies of some kind or showed off their innards in imitation of Salvador Dali's *Venus de Milo with drawers*.[9]

As sole explanation, Dr von Hagens resorted to the modern buzzword: '*It's about breaking the last remaining taboos*', he says . . . A kind of slide occurs as a result of this Mannheim terrorist manifesto, just as it does with the exhibition '*Sensation*' in London and New York: it will not be long before we are forced to acknowledge that the German Expressionists who called for murder were not the only avant-garde artists. By the same token so were people like Use Koch, the blonde romantic who, in 1939, settled in a gloomy valley near Weimar where Goethe once liked to walk and where, more to the point, he dreamed up his MEPHISTOPHELES – *that spirit that denies all*. The place was Buchenwald.

The woman they would call 'the Bitch Dog of Buchenwald' actually enjoyed aesthetic aspirations pretty similar to those of the good Dr von Hagens, for she had certain detainees sporting tattoos skinned so that she could turn their skins into various objects of art brut, as well as lampshades.

'*The painter brings his body with him first and foremost*', wrote Paul Valéry. In the course of the 1960s and 1970s, the painters of the *Wiener Aktionismus*, or Viennese Actionism, would follow this dictum to the letter, using their own bodies as the 'support surface' of their art.

Hermann Nitsch's Orgies Mysteries Theatre 'masses', in which he sacrificed animals in a bloody and bawdy ritual, were followed by what no doubt takes the cake as the most extreme case of AUTO-DA-FÉ by any artist. The story goes that Rudolf Schwarzkogler actually died after a bout of castration he inflicted on himself during one of his performance pieces that took place without a single viewer in the *huis clos* between the artist and a video camera.

This is TERMINAL ART that no longer requires anything more than the showdown between a tortured body and an automatic camera to be accomplished.

At the close of the twentieth century, with Stelarc, the Australian adept at 'body art', the visual arts Schopenhauer wrote were '*the suspension of the pain of living*' would turn into a headlong rush towards pain and death for

individuals who have gradually developed the unconsidered habit of leaving their bodies not so much 'to science' as to some sort of clinical voyeurism – harking back to the heyday of a certain Dr Josef Mengele who performed experiments we all know about, AUSCHWITZ-BIRKENAU for a time becoming *the biggest genetic laboratory in the world.*[10]

'Immediacy is a fraud', Father Dietrich Bonhöffer declared before disappearing in the camp at Flossenburg in 1945 . . . Well, art is every bit as much of a fraud as amnesiac immediacy.

If *'everything is ruled by lightning'*, as Heraclitus suggested, the PHOTOFINISH imposes the instantaneity of its violence on all the various 'artistic representations' and modern art, like war – BLITZKRIEG – is no more than a kind of exhibitionism that imposes its own terrorist voyeurism: that of *death, live.*

By way of illustrating the path the *impiety of art* has taken in the twentieth century, let's look at two types of funerary imagery back to back, though these are separated by almost 2,000 years. The first are the famous PORTRAITS OF THE FAYOUM in Upper Egypt; the second, the PHOTOFINISHES of the Tuol Sleng Memorial in Phnom Penh, where the Angkar – the government of 'Democratic Kampuchea' – had thousands of innocents *put to death in cold blood*, women and children first . . . carefully photographing them beforehand.[11]

In Egypt at the dawn of Western history, people forced themselves to drag the deceased out of anonymity and into the public eye – as an image – in order to identify *the essential being.* In Cambodia at the going down of a pitiless century, *the photographic identity of the detainee was filed before they were put to death.*

In the twinkling of an eye we have, on the one hand, the birth of the *portrait* in all its humility, its discretion.[12] On the other, systematic use of the *freeze frame* as a death sentence revealing THE LOOK OF DEATH.

Two versions of an 'art' that French artist Christian Boltanski has tried to pull off according to his own lights in order to fend off forgetting, negation: this *aesthetic of disappearance* that, alas, simply provides a cover for those who still, even now, reject *the impiety of art.*

It is better to be an object of desire than pity, they say . . . Once the province of advertising, this adage surely now belongs to the realm of art, the desire to consume yielding to the desire to rape or kill. If this really is the case, the academicism of horror will have triumphed, the *profane* art of modernity bowing down before the *sacred* art of conformism, its primacy, a conformism that always spawns ordinary everyday fascism.

How can we fail to see that the mask of *modernism* has been concealing the most classic *academicism*: that of an endlessly reproduced standardization of opinion, the duplication of 'bad feelings' identically reproducing the duplication of the 'good feelings' of the official art of yore?

How can we ultimately fail to twig that the apparent impiety of contemporary art is only ever the inverted image of *sacred art*, the reversal of the creator's initial question: *why is there something instead of nothing?*

Finally, just like the mass media, which no longer peddle anything other than obscenity and fear to satisfy the ratings, contemporary nihilism exposes the drama of an aesthetic of disappearance that no longer involves the domain of representation exclusively (political, artistic, and so on) but our whole vision of the world: visions of every kind of excess, starting with advertising outrages that ensure the succes de scandale without which the conditioning of appearances would immediately stop being effective.

And speaking of disappearance and decline, note the underhand way the *naif* painters have been bundled away: without wanting to wheel out yet again the 'Douanier' Rousseau, whose masterwork, *War*, inspired Picasso's *Guernica*, think of painters like Vivin or Bauchant.

Why the Freudian lapse? This discreet elimination of painters who never laid claim to any *art savant*, whether academic or avant-garde? Do we really believe that this trend of art's towards ingenuity suddenly stopped in its tracks, *decidedly too pitiful* like that *ingehu libertin*, Raoul Dufy?

It will not be long before the drawings of kindergarten children are banned, replaced by digital calligraphic exercises.[13]

Meanwhile, let's get back to art's fraudulent immediacy, to the PRESENTATION of works that supposedly come across as obvious to all and sundry without requiring the intercession of any form of reflection. Here's Marshall McLuhan, that bucolic prosateur of the 'global village': '*If we really want to know what's going on in the present, we should first ask the artists*; they know a lot more than scientists and technocrats *since they live in the absolute present*.'

Here we find the same line of thought as René Gimpel's – only, deformed by the Canadian sociologist's media-haunted ideology. What is this ABSOLUTE PRESENT (that 'absolute' is surely tautological!) if not the resurgence of a classicism that already laid claim to the *eternal present* of art, even going so far as to freeze it in geometric standards (witness the Golden Mean) bearing no relationship to the relative and ephemeral nature of analogical perception of events. *Impressionism* would try to free us from these standards, on the threshold of industrial modernity.

Contrary to appearances, REAL TIME – this 'present' that imposes itself on everyone in the speeding-up of daily reality – is, in fact, only ever the repetition of the splendid academic isolation of bygone days. A mass media academicism that seeks to freeze all originality and all poetics in the inertia of immediacy.

'*Inertia is a raw form of despair*', Saint-Exupéry claimed, at the end of his life.[14] This goes some way to explaining the relentless desire not to save phenomena, as in the past, but to shed them, to spirit them away behind the artifice of the manipulation of signs and signals by a *digital* technology that has now sunk its teeth into the whole array of artistic disciplines, from the taking of photographs to the capturing of sounds. Things have reached such a pitch that a *pitiful* musician par excellence like Bob Dylan can bemoan the fact that

All the music you hear these days is just electricity! You can't hear the singer breathing anymore behind this electronic wall. You can't hear a heart beating anymore. Go to any bar and listen to a blues group and you'll be touched, moved. Then listen to the same group on a CD and you'll wonder where the sound you heard in the bar disappeared to.

The demise of the relative and analogical character of photographic shots and sound samples in favour of the absolute, digital character of the computer, following the synthesizer, is thus also the loss of the poetics of the ephemeral. For one brief moment *Impressionism* – in painting and in music – was able to retrieve the flavour of the ephemeral before the *nihilism* of contemporary technology wiped it out once and for all.

'We live in a world traversed by a limitless destructive force', reckoned Jonathan Mann, the man in charge of the World Health Organization's fight against AIDS, before he disappeared, a victim of the crash of Swissair Flight 111.

Impossible indeed to imagine the art of the twentieth century without weighing the threat of which it is a prime example. A quiet yet visible, even blinding, threat.[15] In the wake of the *counter culture*, aren't we now at the dawning of a culture and an art that are *counter-nature*?

That, in any case, was the question that seemed to be being posed by a conference held at the Institut Heinrich Heine in Paris in the winter of 1999. The title of the conference was: 'The Elimination of Nature as a Theme in Contemporary Art'.

As far as contemporary science and biology go, doubt is no longer an option, for genetics is on the way to becoming an art, a *transgenic art*, a culture of the embryo to purely performative ends, just as the eugenicists of the beginning of the twentieth century hoped. When Nietzsche decided that 'moral judgements, like all religious judgements, belong to ignorance', he flung the door to the laboratories of terror wide open.

To demonstrate or to 'monstrate', that is the question: whether to practise some kind of aesthetic or ethic demonstration or to practise the cleansing of all 'nature', all 'culture', through the technically oriented efficiency of a mere 'monstration', a show, a blatant presentation of horror.

The expressionism of a MONSTER, born of the labour of a science deliberately deprived of a conscience . . . As though, thanks to the progress of genetics, teratology had suddenly become the SUMMUM of BIOLOGY and the oddball the new form of genius – only, not a literary or artistic genius anymore, but a GENETIC GENIUS.

The world is sick, a lot sicker than people realise. That's what we must first acknowledge *so that we can take pity on it*. We shouldn't condemn this world so much as feel sorry for it. *The world needs pity*. Only pity has a chance of cobbling its pride.

So wrote George Bernanos in 1939 . . . Sixty years on, the world is sicker still, but scientist propaganda is infinitely more effective and anaesthesia has the territory covered. As for pride, pride has gotten completely out of hand, thanks to globalization; and *pity* has now bitten the dust just as *piety* once succumbed in the century of philo-folly à la Nietzsche.

They say the purpose of ethics is to slow down the rate at which things happen. Confronted by the general speeding-up of phenomena in our hypermodern world, this curbing by conscience seems pretty feeble.

We are familiar with *extreme sports*, in which the champion risks death striving for some pointless performance – 'going for it'. Now we find the man of science, adept in *extreme sciences*, running the supreme risk of denaturing the living being – having already shattered his living environment.

Thanks to the decryption of the map of the human genome, geneticists are now using cloning in the quest for the *chimera*, the hybridization of man and animal. How can we fail to see that these 'scientific extremists', far from merely threatening the unicity of the human race by trafficking embryos, are also taking their axe to the whole philosophical and physiological panoply

that previously gave the term SCIENCE its very meaning? In so doing, they threaten science itself with disappearance.

Extreme arts, such as transgenic practices, aim at nothing less than to embark BIOLOGY on the road to a kind of 'expressionism' whereby teratology will no longer be content just to study malformations, but will resolutely set off in quest of their chimeric reproduction.

As in ancient myths, science, thus enfeebled, will once more become the 'theatre of phantasmatic appearances' of chimera of all kinds. And so the engendering of monsters will endeavour to contribute to the malevolent power of the demi-urge, with its ability to go beyond the physiology of the being. Which is only in keeping with what was already being produced by the German Expressionism denounced by René Gimpel. But also, first and foremost, by the horror of the laboratories of the extermination camps.

It is no longer enough now to oppose negationism of the Shoah; we also need to categorically reject negationism of art – by rejecting this 'art brut' that secretly constitutes *engineering of the living*, thanks to the gradual decryption of DNA; this 'eugenics' that no longer speaks its name yet is gearing up all the same to reproduce the abomination of desolation, not just by putting innocent victims to death anymore but by *bringing* the new HOMUNCULUS *to life*.

In 1997, a member of the French National Ethics Committee, Axel Kahn, wrote of cloning: 'It is no longer a matter of tests on a man but of actual tests for a man. That a life so created is now genetically programmed to suffer abnormally – this constitutes absolute horror'.[16]

How can we fail to see here the catastrophic continuation of Nazi experimentation, experimentation destined as a priority for the pilots of the Luftwaffe and the soldiers of the Wehrmacht, those *supermen* engaged body and soul in a total war?

In Hitler's time, Professor Eugen Fischer, founder and director of the 'Institute of Anthropology, Human Genetics and Eugenics (IEG), declared that animal experiments still dominated research only because we have very limited means of obtaining human embryonic material'.[17] Fischer went on to say that, 'When we have done with research on rabbits, which remains the main type of research for the moment, we will move on to human embryos'.[18] With the abundant stock of human embryos at the end of the twentieth century this is, alas, a done deal . . .

But stay tuned to what the German geneticist went on to say in 1940. 'Research on twins constitutes the specific method for studying human genetics.'[19] Two years later, Adolf Hitler made Eugen Fischer an honorary

member of the 'Scientific Senate' of the Wehrmacht; he was succeeded as head of the IEG by Professor Otmar von Verschuer, a specialist in twins . . .

From that moment, AUSCHWITZ-BIRKENAU became a research laboratory undoubtedly unique in the world, the laboratory of the 'Institute of Anthropology, Human Genetics and Eugenics'. The name of Professor Verschuer's assistant was Josef Mengele. You know the rest.[20]

As recently as 1998, the British medical weekly *The Lancet* condemned the initiatives of the European Union and the United States in trying to introduce a total ban on the practice of human cloning. A year later, the editors were still arguing that 'the creation of human beings' had become 'inevitable', regardless. The editors of the London publication wrote that:

> The medical community will one day have to address the care of and respect for people created by cloning techniques. That discussion had better begin now, before the newspaper headlines roll over the individuality of the first person born this way.[21]

They went on to stress that, all in all, 'there is no difference between an identical twin and a clone (delayed identical twin)'.[22]

It is not too hard to imagine the consequences of this confusion between PROCREATION and CREATION, of the demiurgic pretensions of a eugenics that no longer has any limits. Now that *medically assisted procreation* of the embryo has led to *genetically programmed creation* of the double, the gap between HUMAN and TRANSHUMAN has been closed just as those old New Age disciples had hoped; and the celebrated British review *The Lancet* can arrogate to itself the exorbitant right to remove the term INHUMAN from our vocabulary!

Sir Francis Galton, the unredeemed eugenicist, is back in the land of his cousin Darwin: *freedom of aesthetic expression* now knows no bounds. Not only is everything from now on 'possible'. It is 'inevitable'!

Thanks to the genetic bomb, the science of biology has become a major art – only, an EXTREME ART.

This helps make sense of the title of that Heinrich Heine Institute conference, 'The Elimination of Nature as a Theme in Contemporary Art'. It also makes sense of the recent innovation not only of a COUNTER CULTURE, opposed to the culture of the bourgeoisie, but also of an art that is frankly COUNTER-NATURE, peddling as it does a eugenics that has finally triumphed over all prejudice absolutely, in spite of the numberless horrors of the waning century.

Having *broken the taboos* of suffocating bourgeois culture, we are now supposed to *break the being*, the unicity of humankind, through the impending explosion of a genetic bomb that will be to biology what the atomic bomb was to physics.

You don't make literature out of warm and fuzzy feelings, they say. And they are probably right. But how far do we go in the opposite direction? As far as SNUFF LITERATURE, in which the conformism of abjection innovates an academicism of horror, an official art of macabre entertainment? In the United States, to take one example, the torturing of the human body by sharp instruments seems to have become the preferred image of advertising, according to the *Wall Street Journal* of 4 May 2000.

Hit over the head by such media bludgeoning, the art lover is surely already the victim of what psychiatrists call *impaired judgement*. Which is the first step in an accelerated process of derealization, contemporary art accepting the escalation in extremism and therefore in insignificance, with significance going the way of the 'heroic' nature of old-fashioned official art, and obscenity now exceeding all bounds with SNUFF MOVIES and death, live . . .

Let's turn now to contemporary theatre and dance, in particular the work of choreographer Meg Stuart. Since the early 1990s, Stuart has been taking her stage performance to the limit. In *Disfigured Study* of 1991, the dancer's skin looked like it was straining to contain a body in the process of dislocating itself in a brutal vision of automatic self-mutilation. Devastated bodies seemed like so many panicky signs of a live spectacle in which 'the catastrophic intensity condenses a terrifying serenity at the edge of the abyss' – as you could read in the press apropos Stuart's most recent work, *Appetite*, conceived with the installation artist Ann Hamilton.

In work like this, everything is dance, dance involving 'bodies without hands, twisted legs, wavering identity expressing who knows what self-hatred'.[23] After the SNUFF VIDEO, we now have the SNUFF DANCE, the dance of death of the slaughterhouses of modernity.

Whether Adorno likes it or not, the spectacle of abjection remains the same, after as before Auschwitz. But it has become politically incorrect to say so. All in the name of freedom of expression, a freedom contemporary with the terrorist politics Joseph Goebbels described as 'the art of making possible what seemed impossible'.[24]

But let's dispel any doubts we might still have. Despite the current negationism, freedom of expression has at least one limit: *the call to murder and torture*. Remember the *media of hate* in the ex-Yugoslavia of Slobodan

Milosovic? Remember the 'Thousand Hills Radio' of the Great Lakes region of Africa calling Rwandans to inter-ethnic genocide? Confronted by such 'expressionist' events, surely we can see what comes next, looming over us as it is: *an officially terrorist art* preaching suicide and self-mutilation – thereby extending the current infatuation with scarring and piercing. Or else random slaughter, the coming of a THANATOPHILIA that would revive the now forgotten fascist slogan: *VIVA LA MUERTA!*

At this point we might note the project of the multinational Monsanto designed to genetically programme crop sterilization and designated by the telling name TERMINATOR. Are we still talking biotechnology here? Aren't we really talking about a form of *necro-technology* aimed at ensuring one firm's monopoly?

Thanatophilia, necro-technology and one day soon, teratology . . . Is this genetic trance still a science, some new alchemy, or is it *an extreme art*?

For confirmation we need look no further than the Harvard Medical School where Malcolm Logan and Clifford Tabin recently created a mutation that says a lot about the fundamentally expressionist nature of genetic engineering.

> After locating a gene that seemed to play a decisive role in the formation of a chicken's hindlimbs, Logan and Tabin took the radical step of introducing the gene into the genome of a virus which they then injected into the developing wings of a chicken embryo to test the function of the gene.[25]

Some weeks later, this TERATOLOGICAL breakthrough made headlines.

> The chicken's wings have undergone major transformations and now look like legs, with the wing twisted into a position suitable for walking and the fingers pivoting to facilitate pressure on the ground. The placement of the muscles is radically different, too, better adapted to the specific functions of walking.[26]

But this monster is not yet perfect, however, for its Kafkaesque metamorphosis is incomplete . . . The 'four-legged chicken' is in fact an experimental failure worthy of featuring in the bestiary of a Jerome Bosch! After the 'Doctor Strangeloves' of the atomic bomb, voilà 'Frankenstein', no less: *the monster has become the chimerical horizon of the study of malformations.*

And it won't be long before human guinea pigs are used instead of animals in future experiments. Let's hear it from those trying to denounce this drift of *genetic expressionism*, from the inside:

> The dazzle of success is goading biologists implacably on, each obstacle overcome leading them to take up the next challenge – a challenge *even greater, even more insane?* We should note that if this challenge is not met, the consequences will not be felt by the biologists alone but also by this improbable and uncertain child whose birth they will have enabled in spite of everything.

So writes Axel Kahn apropos 'medically assisted pro-creation'. Kahn concludes, 'Everything in the history of human enterprise would indicate that this headlong rush into the future will one day end in catastrophies – in botched attempts at human beings.'[27]

How can we fail here to denounce yet another facet of negationism: that of the deliberate overlooking of the famous NUREMBURG CODE, set down in 1947 in the wake of the horrors the Nazi doctors perpetrated? 'The Nuremburg Code established the conditions under which tests on human beings could be conducted; it is a fundamental text for modern medical ethics', as Axel Kahn rightly reminds us . . . There is not a hint of respect for any of this in the contemporary trials: 'When will the Nuremburg Code be applied to medically assisted procreation . . . to the attempts at creating a human being?' asks Kahn, as a geneticist and member of the French National Ethics Committee, by way of conclusion.

Ethics or aesthetics? That is indeed the question at the dawn of the millennium. If freedom of SCIENTIFIC expression now actually has no more limits than freedom of ARTISTIC expression, where will *inhumanity* end in future?

After all the great periods of art, after the great schools such as the classical and the baroque, after contemporary expressionism, are we not now heading for that *great transgenic art* in which every pharmacy, every laboratory will launch its own 'lifestyles', its own transhuman fashions? A chimerical explosion worthy of featuring in some future *Salon of New Realities* – if not in a *Museum of Eugenic Art.*

As one critic recently put it: '*Artists have their bit to say about the laws of nature at this fin de siècle.*' What is urgently required is '*to define a new*

relationship between species, one that is not conceived in the loaded terms of bestiality.[28]

It is not entirely irrelevant to point out here that if 'extreme sports' came before 'extreme sciences', there is a good reason for this, one that has to do with the cult of performance, of *art for art's sake*, the breaking of records of every imaginable kind.

When it comes to the ingestion of certain substances by top-level sportspeople, a number of trainers are already asking about limits. 'We are at the beginnings of biological reprogramming yet we don't know how far we are not going to be able to go.' Beyond the drug tests and medical monitoring that champions are already subject to, the general lack of guidelines opens the way to genetic manipulation and cellular enhancement as well as doping on a molecular level. According to Gérard Dine, head of the 'Mobile Biological Unit' launched by the French Minister of Youth and Sport:

> Sportspeople are managed by an entourage who are under more and more pressure from the media and their financial backers. If the current debate isn't settled pretty swiftly, a person will only have to ask in order to be programmed to win.

'*The assembly-line champion is already on the drawing board*. Soon we will even be able to intervene with precision on energy levels and mechanical, muscular and neurological elements', one expert claims. After all, the German Democratic Republic did it in the 1970s using synthetic hormones, but these left a trace. Thanks to genomics, you can now enter the human system in the same way as you break into a computer bank – without leaving any trace at all.

'The lack of guidelines requires us urgently to define *an ethical boundary that would make clear what comes under therapy and what is out of bounds*.'[29]

If we do not put in place some sort of code that would extend what was covered by the Nuremburg Code in the area of experimentation on top-level sportspeople, the Olympic Games of the year 2020 or 2030, say, will be mere *games of the transgenic circus* in which the magicians of the human genome will hold up for our applause the exploits of the *stadium gods* of a triumphant super-humanity.

Ethical boundary, aesthetic boundary of sport as of art. Without limits, there is no value; without value, there is no esteem, no respect and especially no pity: *death to the referee!* You know how it goes . . .

Already, more or less everywhere you turn, you hear the words that precede that fatal habituation to the banalization of excess. For certain philosophers the body is already no more than a phenomenon of memory, *the remnants of an archaic body*; and the human being, a mere biped, fragile of flesh and so slow to grow up and defend itself that the species should not have survived . . .

To make up for this lack, this 'native infirmity' as they call it, echoing a phrase used by Leroi-Gourhan, man invented tools, prostheses and a whole technological corpus without which he would not have survived . . . But this is a restrospective vision incapable of coming to terms with the outrageousness of the time that is approaching. Géricault, Picasso and Dali, Galton and Mengele . . . Who comes next?

Where will it end, this impiety of art, of the arts and crafts of this 'transfiguration' that not only fulfils the dreams of the German Expressionists but also those of the Futurists, those 'hate-makers' whose destructiveness Hans Magnus Enzensberger has dissected.

Remember Mayakovsky's war cry, that blast of poetic premonition: 'Let your axes dance on the bald skulls of the well-heeled egoists and grocers. Kill! Kill! Kill! One good thing: their skulls will make perfect ashtrays.'[30]

Ashtrays, lampshades, quotidian objects and prostheses of a life where the banality of evil, its ordinariness, is far more terrifying than all the atrocities put together, as Hannah Arendt noted while observing the trial of Adolf Eichmann in 1961.

Under the reign of Pol Pot's Democratic Kampuchea, the hopes of the poet of the October Revolution were satisfied yet again, though it was with spades, not axes, that the self-mutilation of a social body of nearly two million Cambodians was perpetrated. 'The murderers did not use firearms. The silence, they knew, added further to the climate of terror.'[31]

The silence of the lambs still required the silence of the executioners. The silence of an untroubled conscience, such as that enjoyed by a so-called 'political science' now disowned by former 'revolutionary' Ieng-Sary who today declares, apparently by way of excuse, 'The world has changed. I no longer believe in the class struggle. The period from 1975 to 1979 was a failure. We went from Utopia to barbarity.'[32]

Meanwhile, Tuol Sleng has become a museum – a genocide museum. The sinister Camp-S21 (Security Office 21), where the gaolers were teenagers, offers visitors a tour of the gallery of photographic portraits of its multitudinous victims. Here, contrary to the German extermination camps, the bodies have disappeared, but the faces remain . . .

SILENCE ON TRIAL

'*Remaining silent, now there's a lesson for you! What more immediate notion of duration?*', Paul Valéry noted in 1938, shortly before the tragedy of the camps, the silence of the lambs . . .

To speak or *to remain silent*: are they to sonority what *to show* or *to hide* are to visibility? What prosecution of meaning is thus hidden behind the prosecution of sound? Has remaining silent now become a discreet form of assent, of connivance, in the age of the sonorization of images and all audio-visual icons? Have vocal machines' powers of enunciation gone as far as the denunciation of silence, of a silence that has turned into MUTISM?

It might be appropriate at this juncture to remember Joseph Beuys whose work *Silence* parallels, not to say echoes, Edvard Munch's 1883 painting *The Scream*. Think of the systematic use of felt in Beuys' London installations of 1985 with the gallery spaces wadded like so many SOUNDPROOF ROOMS, precisely at a time when the deafening explosion of the AUDIO-VISUAL was to occur – along with what is now conveniently labelled the crisis in modern art or, more exactly, *the contemporary art of the crisis of meaning*, that NONSENSE Sartre and Camus were on about.

To better understand such a heretical point of view about the programmed demise of the VOICES OF SILENCE, think of the perverse implications of the *colouration of films* originally shot in BLACK AND WHITE, to cite one example, or the use of monochromatic film in photographing accidents, oil spills. The lack of colour in a film segment or snapshot is seen as the tell-tale sign of a DEFECT, a handicap, the loss of colour of the rising tide under the effects of maritime pollution . . .

Whereas in the past, engraving enriched a painting's hues with its velvety blacks and the rainbow array of its greys, BLACK – and WHITE – are now no more than traces of a degradation, some premature ruin.

Just like a yellowed photograph of the deceased mounted on their tomb, the MONOCHROMATIC segment merely signals the obscurantism of a bygone era, the dwindling of a heroic age in which the VISION MACHINE had yet to reveal the PANCHROMATIC riches of Technicolor . . . gaudy, brash AGFACOLOR[1] over-privileging hot colours to the detriment of cold.

But surely we can say the same thing about the sonorization of what were once *silent films*.

Nowadays everything that remains silent is deemed *to consent*, to accept without a word of protest the background noise of audio-visual immoderation – that is, of the 'optically correct'. But what happens as a result to the SILENCE OF THE VISIBLE under the reign of the AUDIO-VISIBLE epitomized by *television*, wildly overrated as television is? How can we apply the lesson of Paul Valéry's aphorism in considering the question, not of the *silence of art* so dear to André Malraux, but of the DEAFNESS of the contemporary arts in the age of the multimedia?

Silence no longer has a voice. It LOST ITS VOICE half a century ago. But this mutism has now come to a head . . . The voices of silence have been silenced; what is now regarded as obscene is not so much the image as the sound – or, rather, the lack of sound.

What happens to the WORLD OF SILENCE once the first SON ET LUMIÈRE productions are staged, again under the aegis of Malraux, invading as they do the monumental spaces of the Mediterranean? The 'son et lumière' phenomenon has been followed most recently by the craze in museums as venues for live shows, though you would be hard-pressed to beat the calamitous NIGHT OF THE MILLENNIUM, when the mists of the Nile Valley suddenly broke up a Jean-Michel Jarre concert. After the deafening felt of Beuy's London installation, PLIGHT, they managed to bring SMOG to the foot of the pyramids.

'I don't want to avoid telling a story, but I want very, very much to do the thing Valéry said – to give the sensation without the boredom of its conveyance.' These words of Francis Bacon's, taken from David Sylvester's interviews with the artist and quoted as a lead-in for the '*Modern Starts*' exhibition at the Museum of Modern Art in New York, 1999, beautifully sum up the current dilemma: the less you represent, the more you push the simulacrum of REPRESENTATION!

But what is this 'situation' concealing if not the *contraction of time?* Of this *real time* that effaces all duration, exclusively promoting instead the *present*, the directness of the immediacy of ZERO TIME . . . a contraction of the LIVE and of LIFE, which we see once more at work in the recent appeal of *live shows*, which are to dance and choreography what the video installation already was to Fernand Léger's *Mechanical Ballet*.

All in all, the invention of the CINEMATOGRAPH has radically altered the experience of *exposure time*, the whole regime of temporality of the

visual arts. In the nineteenth century, the aesthetics of CINEMATIC disappearance promptly supplanted the multimillennial aesthetics of the appearance of the STATIC.

Once the photogram hit the scene, it was solely a matter of mechanically or electrically producing some kind of *reality effect* to get people to forget the lack of any subject as the film rolled past.

Yet one crucial aspect of this mutation of the seventh art has been too long ignored and that is the arrival of the TALKIES. From the end of the 1920s onwards, the idea of accepting the absence of words or phrases, of some kind of dialogue, became unthinkable.[2] The so-called *listening comfort* of darkened cinema halls required that HEARING and VISION be *synchronized*. Much later, at the end of the century, ACTION and REACTION similarly would be put into instant *interaction* thanks to the feats of 'tele-action', this time, and not just radiophonic 'tele-listening' or 'tele-vision'.

Curiously, it is in the era of the Great Depression that followed the Wall Street Crash of 1929 that SILENCE WAS PUT ON TRIAL – in Europe as in the United States. From that moment, WHOEVER SAYS NOTHING IS DEEMED TO CONSENT. No silence can express disapproval or resistance but only consent. The silence of the image is not only ANIMATED by the motorization of film segments; it is also ENLISTED in the general acquiescence in a TOTAL ART – the seventh art which, they would then claim, contained all the rest.

During the great economic crisis which, in Europe, would end in Nazi TOTALITARIANISM, silence was already no more than a form of abstention. The trend everywhere was towards the *simultaneous* synchronization of image and sound. Whence the major political role played at the time by cinematic NEWSREELS, notably those produced by Fox-Movietone in the United States and by UFA in Germany, which perfectly prefigured televisual *prime time*.

Alongside booming radiophony and the *live rallies* of Nuremburg and elsewhere, the talkies would become one of the instruments of choice of the fledgling totalitarianisms. For Mussolini, *the camera was the most powerful weapon there was*; for Stalin, at the same moment in time, *the cinema was the most effective of tools for stirring up the masses*.

No *AGITPROP* or *PROPAGANDA STAEFFEL* without the *consensual power of the talkies*. Once you have the talkies up and running, you can get walls, any old animated image whatever to talk. The *dead* too, though, and *all who remain silent*. And not just people or beings, either, but things to boot!

'*The screen answers your every whim, in advance*', as Orwell put it. Yet though the walls may well talk, frescos no longer can. The seventh art thus

becomes a VENTRILOQUIST ART delivering its own oracles. Like the Pythian prophetess, the image speaks; but, more specifically, it *answers* the silence of the anguished masses who have lost their tongues. As a certain poet put it, '*Cinema never has been SILENT, only DEAF*'.

Those days are long gone. No one is waiting any more for the REVOLUTION, only for the ACCIDENT, the breakdown, that will reduce this unbearable chatter to silence.

In olden days a pianist used to punctuate segments of old burlesque movies; now the reality of scenes of everyday life needs to be subtitled in similar vein, the AUDIO-VISUAL aiming to put paid to the *silence of vision* in its entirety.

All you have to do is dump your mobile phone and grab your infra-red helmet. Then you are ready to go wandering around those museums where the *sound-track* amply makes up for the *image track* of the picture-rail.

Does art mean listening or looking, for the art lover? Has contemplation of painting become a reflex action and possibly a CYBERNETIC one at that?

Victim of the *prosecution of silence*, contemporary art long ago made a bid for *divergence* – in other words, to practise a CONCEPTUAL DIVERSION – before opting for *convergence*.

Surely that is the only way we can interpret the Cubists' newspaper collages or the later, post-1918, collages and photomontages of Raoul Hausmann, say, or his Berlin Dadaist confrère, John Heartfield, not to mention the French Dadaists and Surrealists, among others.

In a decidedly fin de siècle world, where the automobile questions its driver about the functioning of the handbrake or whether the seatbelt is buckled, where the refrigerator is gearing itself up to place the order at the supermarket, where your computer greets you of a morning with a hearty 'hello', surely we have to ask ourselves whether the silence of art can be sustained for much longer.

This goes even for the mobile phone craze that is part and parcel of the same thing, since it is now necessary to *impose silence* – in restaurants and places of worship or concert halls. One day, following the example of the campaign to combat nicotine addiction, it may well be necessary to put up signs of the 'Silence – Hospital' variety at the entrance to museums and exhibition halls to get all those 'communication machines' to shut up and put an end to the all too numerous cultural exercises in SOUND and LIGHT.

Machine for *seeing*, machine for *hearing*, once upon a time; machine for *thinking* very shortly with the boom in all things *digital* and the programmed

abandonment of the *analogue*. How will *the silence of the infinite spaces of art* subsist, this silence that seems to terrify the makers of motors of any kind, from the logical inference motor of the computer to the research engine of the network of networks? All these questions that today remain unanswered make ENIGMAS of contemporary ethics and aesthetics.

With architecture, alas, the jig is already up. Architectonics has become an *audio-visual art*, the only question now being whether it will shortly go on to become a VIRTUAL ART. For sculpture, ever since Jean Tinguely and his 'Bachelor Machines', this has been merely a risk to be run. As for painting and the graphic arts, from the moment VIDEO ART hit the scene with the notion of the installation, it has been impossible to mention CONCEPTUAL ART without picking up the background noise of the mass media behind the words and objects of the art market.

Like TINNITUS, where a ringing in the ears perceived in the absence of external noise soon becomes unbearable, contemporary art's *prosecution of silence* is in the process of lastingly polluting our representations.

Having digested the critical impact of Marcel Duchamp's retinal art, let's hear what French critic Patrick Vauday had to say a little more recently:

> The passage from image to photography and then to cinema and, more recently still, to video and digital computer graphics, has surely had the effect of rendering painting magnificently *célibataire*. Painting has finally been released from the image-making function that till then more or less concealed its true essence. Notwithstanding the 'new' figurative art, it is not too far-fetched to see in the modern avatar of painting a *mise à nu* of its essence that is resolutely ICONOCLASTIC.[3]

At those words, you could be forgiven for fearing that the waxing twenty-first century were about to reproduce the first years of the twentieth, albeit unwittingly!

Under the guise of 'new technologies', surely what is really at work here is the actual CLONING, over and over, of some SUPER-, no, HYPER-ABSTRACTION that will be to virtual reality what HYPER-REALISM was to the photographic shot. This is happening at a time when someone like Kouichirou Eto, for instance, is gearing up to launch SOUND CREATURES on the Internet along with his own meta-musical ambient music!

What this means is a style of painting not only *without figures* but also *without images*, a *music of the spheres without sound*, presenting the symptoms of a *blinding* that would be the exact counterpart to the *silence of the*

lambs. Speaking of the painter Turner, certain nineteenth-century aesthetes such as Hazlitt denounced the advent of '*pictures of nothing, and very like*'.[4] You can bet that soon, thanks to digital technology, *electro-acoustic* music will generate new forms of visual art. *Electro-optic* computer graphics will similarly erase the demarcation lines between the different art forms.

Once again, we will speak of a TOTAL ART – one no longer indebted to the cinematograph, that art which supposedly contained all the rest. Thanks to electronics, we will invent a GLOBAL ART, a 'single art', like the thinking that subtends the new information and communications technologies.

To take an example, think of the influence of Wagner on Kandinsky in 1910, when the very first ABSTRACT canvases emerged; or think of the influence of Kurt Schwitters whose *Ursonate* was composed of oral sounds . . . Then, of course, there is the influence of JAZZ on works like the 'Broadway Boogie Woogie' of New York based Mondrian, an artist who would not have a telephone in the house during the years 1940 to 1942. Unlike Moholy-Nagy, who was already making TELE-PAINTINGS twenty years earlier using the crank phone to issue instructions at a distance to a sign painter . . . and inventing pictorial INTERACTIVITY in the process.

All this interaction between SOUND, LIGHT and IMAGE, far from creating a 'new art' or a *new reality* – to borrow the name of the 1950 Paris salon dedicated to French painter Herbin's geometric abstraction – only destroys the nature of art, promoting instead its communication.

Moreover, someone like Andy Warhol makes no sense as an artist in the Duchamp mould unless we understand the dynamic role played not only by sign painting, but more especially by advertising, that last ACADEMICISM that has gradually invaded the temples of *official art* without anyone's batting an eyelid. So little offence has it given, in fact, that where 'Campbell's Soup' not so long ago turned into a *painting*, today Picasso has become a *car*.

Last autumn, the BBC began broadcasting recordings of murmurs and conversation noises destined for the offices at the big end of town where employees complain about the reigning deathly silence.

'We're trying to get a background of ambient sound', explains a spokesman for the British station. 'These offices are so quiet that the slightest noise, such as the phone ringing, disturbs people's concentration which, of course, can lead to stuff-ups.'[5]

Following the muzak that is piped through shops and supermarkets, let's hear it for AMBIENT MURMURING, *the voice of the voiceless!* After the promotion of domestic consumerism via the euphoria of radiophony, it is

now production that finds itself beefed up with a sound backdrop designed to improve office life . . .

Similarly, over at the Pompidou Centre in Paris, the post-renovation reopening exhibition, which was called 'Le Temps vite' – or 'Time, Fast' – was underscored by a sound piece composed by Heiner Goebbels.

Heralding the coming proliferation of live shows in museums, silence has become identified with death . . . Though it is true enough that the dead today dance and sing thanks to the recording process: 'Death represents a lot of money, it can even make you a star', as Andy Warhol famously quipped. Don't they also say that, on the night of New Year's Eve 2000, the 'POST-MORTEM' duo of Bob Marley and his daughter-in-law, Lauren Hill, could be heard all over New York?[6]

On the eve of the new millennium, the aesthetics of disappearance was completed by the aesthetics of absence. From that moment, whoever says nothing consents to cede their 'right to remain silent', their freedom to listen, to a noise-making process that simulates oral expression or conversation.

But did anyone in the past ever fret about the very particular silence of the VISIBLE, best exemplified by the pictorial or sculptural image? Think of what August Wilhelm Schlegel once wrote about Raphael's Dresden Madonna. 'The effect is so immediate that no words spring to mind. Besides, what use are words in the face of what offers itself with such luminous obviousness?'[7]

Today, when the AUDIO-VISIBLE of the mass media reigns, beamed out twenty-four hours a day seven days a week, what remains of that effect of immediacy of visual representation? Media presentation dominates everywhere you turn.

Struck 'deaf' and 'dumb' over the course of the waning century, the visual arts have taken a battering, not only from the animated image, but especially from the TALKIES.

Remember, too, what the poet said when he insisted on the fact that so-called SILENT cinema was only ever DEAF, the first cinema-goers of the darkened movie halls being less aware of the actors' lack of words than of their own deafness. The early devotee of the seventh art of cinematography translated the silence of the movies into their own imaginary handicap, their personal limitation in seeing without hearing what the characters up on the screen were saying to each other.

Yet has anyone ever experienced this feeling of infirmity looking at a painting representing singers or angelic musicians? Hardly! So why did the

aesthetics of the animated image suddenly disable the viewer of silent films, rendering strangely deaf a person hitherto not deaf in the slightest?

'Looking is not the same as experiencing', Isabelle Adjani reckons and she would know when it comes to looks. Adjani here goes one further than Kafka, who expressed his specific anxiety to his friend Gustav Janouch, some time in the years between 1910 and 1912:

> '*Cinema disturbs one's vision.* The speed of the movements and the rapid change of images force you to look continuously from one to the next. *Your sight does not master the pictures, it is the pictures that master your sight.* They flood your consciousness. *The cinema involves putting your eyes into uniform, when before they were naked.*'
>
> 'That is a terrible thing to say', Janouch said. '*The eye is the window of the soul*, a Czech proverb says.'
>
> Kafka nodded. 'FILMS ARE IRON SHUTTERS.'[8]

What can you say about the 'talkies' and about the *sound-track* that puts the finishing touches on the effect of mastery of the *image track,* except that they are a lot more harmful than people realize? Must we wheel in radiophony and telephony yet again to explain 'the accident of the visible' that goes by the name of the AUDIO-VISUAL?

Bear in mind Démény's bit of chronophotography in which a man mouths 'je t'aime' to a camera that only records the movement of his lips. We've all seen the smile of the Mona Lisa; here you can see the smile of Etienne-Jules Marey's pretty niece as a prelude to hearing speech enunciated in front of a microphone.

The contemporary crisis in the plastic arts actually started here, *with the enunciation of the image of the TALKIES and the concomitant denunciation of our deafness.* You do not lend speech to walls or screens with impunity – not without also attacking the fresco and mural art and, ultimately, the whole panoply of the parietal aesthetics of architecture every bit as much as painting.

After the *eye, mobilized* by the whipping past of film sequences denounced by Kafka, it is the turn of the *ear, traumatized* suddenly by imaginary deafness. Victim of the war in which the unfolding of time is speeded-up, the field of perception suddenly becomes a real *battlefield*, with its barked commands and its shrieks of terror; whence the quest for the SCREAM as for FEAR conducted by the German Expressionists throughout the traumatic

years of the 1920s and 1930s when the *disqualification of the silence of paintings* would usher in the impending tyranny of mass communications tools.

This bestowing of speech upon images, upon the whirling rush of film, meant unwittingly triggering a phenomenon of panic in which the audiovisual would gradually lead to this silence of the lambs whereby the art lover becomes the victim of sound, a hostage of the sonorization of the visible. In his 1910 tract *Futurist Painting: Technical Manifesto*, Marinetti, after all, declared, 'Our sensations must not be whispered; we will make them sing and shout upon our canvases in deafening and triumphant fanfares.'

The key term here is this WE WILL, expressing the triumph of the will to wipe out *the voices of silence* through the din of those famous 'noise-making machines' that heralded the ravages caused by the artillery of the Great War.

And so the upheaval in the graphic arts is not to be chalked up to photography or even to cinematography so much as to the TALKIES. As a contrast, both sculpture and architecture were able to dream up and elaborate the myriad metamorphoses of their representations – and this, from the beginning in fact, thanks to a certain cinematic aesthetic.

'To command, you must first of all speak to the eyes', Napoléon Bonaparte decreed. 'The cinema means putting your eyes into uniform', Kafka confirmed. Between these two complementary assertions, oral culture has slowly evaporated, The art of speaking has bowed out before the 'talking' cinema and the oratorical power of the political tribune has been defeated by media culture. From now on, what speaks is the image – any image, from billboard images to images at home on the box.

Wherever TELEPRESENCE has taken over from PRESENCE, whether physical or graphic, silence spreads, endlessly deepening.

Having been wired for sound at the end of the 1920s – in 1927, to be precise, with the film *The Jazz Singer* – the cinematograph has not only pulled blinkers over viewers' eyes – or iron shutters, as Kafka would say. It has also, according to Abel Gance, *stymied looking* – before going on to render the visual arts hoarse and then swiftly dumb.

By indirectly promoting the rise of TOTALITARIANISM, Democratic Germany's 'silent prose-cution' promptly authorized every kind of *negationism*. Bear in mind the confession of the German priest Father Niemoller: 'When they arrested the gypsies, I said nothing. When they arrested the homosexuals, I said nothing. When they deported the Jews, I said nothing. But when they arrested me, the others said nothing.'

Early warning signs of the pitiless nature of MODERN TIMES as portrayed by Charlie Chaplin, the visual arts of that historical period never ceased TORTURING FORMS before making them disappear in abstraction. Similarly others would not cease TORTURING BODIES afterwards to the tune of the screams of the tortured prior to their asphyxiation inside the gas chambers.

On that note, let's hear the testimony of Valeska Gert, the actress who starred in German filmmaker G. W. Pabst's 1925 'street' film *Joyless Street*:

I looked like a poster – that was novel. I would screw my face up into a grimace of indignation one minute, then quietly dance the next. By juxtaposing insolence and sweetness, hardness and charm, without any transition, I represented for the first time something characteristic of our times: *instability*. This was in 1917, towards the end of the war. The Dadaists did the show as a matinee in Berlin and the high point of the programme was a race between a typewriter and a sewing machine. George Grosz was the sewing machine. *I danced to the sound of the two machines.*[9]

A still figure coming to life, silhouettes, shadows flapping about: the *camera obscura* had already been there, done that with the invention of visual perspective. But an animated image, one that talks, calls out to you . . . This was the birth of a sonorous audio-visual perspective that far outdid what instrumental music had already done for the history of oral culture. Suddenly Plato's cave became the Sybil's lair and there was not a thing the visual arts could do about this sudden irruption of the AUDIO-VISIBLE.

When Al Jolson, the white singer who mimicked the movements of a black singer, launched his celebrated '*Hello Mammy*' in the first talking film, in 1927, he was answering the unarticulated scream of Edvard Munch. In 1883, two years before the Lumière brothers invented cinema, Munch had tried to puff up the painted image with a sort of SOUND RELIEF, which was until that moment the sole province of music and its attendant notations.

Similarly, around 1910, newly hatched abstraction would typify the bid for *mental sonorization* in the pictorial realm. Here's the way Kandinsky put it: 'The clearer the abstract element of form, the purer, the more elementary, the sound.'

An adept of the then very recent discoveries in the psychology of perception, this pioneer of abstraction would seek to clear the field of all the formal references of figurative art. In the peculiar manner of the Berlin School's

GESTALTHEORIE, Kandinsky would tirelessly pursue 'the right form': a pictorial language 'that everyone can understand'.

It is worth noting in this regard that, contrary to the romantic notion previously expressed by Schlegel, art's most serious drawback is its immediacy, its ability to be perceived *at a glance*.

While theatre and dance – those arts involving immediate presence – still demand prolonged attention, we sum up the visual arts immediately, or as good as. The very recent development of REAL-TIME computer imagery only ever accentuates this effect of iconic stupefaction.

Whence contemporary art's shrillness in its bid to be heard *without delay* – that is, *without necessitating attention*, without requiring the onlooker's prolonged reflection and instead going for the conditioned reflex, for a reactionary and simultaneous activity.

And strangely, as British art historian Norbert Lynton notes:

> Since the thirties, we have spoken more and more often also of another sort of commitment. We want the artist not only to give himself wholly in his art and to his art; we also want him to dedicate his resources to political progress. For too long, the argument goes, has art been an ornament and a diversion; the time has come for the artist to accept adult responsibilities and to make art a weapon. *Art that does not help in the fight diverts attention from it.*[10]

This declaration of hostility towards the prolonged attention of an ONLOOKER, who then finds him- or herself defined as MILITANT, if not MILITARY – *in any case, as militating against the law of the silence of art* – is typical of a 'futurism' for which war was the world's only hygiene. It could only end up disempowering the graphic arts due to their lack of sound.

For if certain works SPEAK, those that SHOUT and SCREAM – their pain or hate – would soon abolish all dialogue and rule out any form of questioning.

The way that pressure from the media audience ensures that crime and pornography never cease dominating AUDIO-VISUAL programmes – so much so that our screens have reached saturation point these days, as we all know – the bleak dawn of the twentieth century was not only to inaugurate the crisis in figurative representation, but along with it, the crisis in *social stability* without which *representative* democracy in turn disappears.

To thus vociferously denounce OMERTA, *this law of the silence of art*, and promote instead some so-called 'freeing up of speech', was to trigger a

system of informing that George Orwell would later portray to perfection. NEWSPEAK, the language Orwell invented in his novel *Nineteen-Eighty-Four*, beautifully exemplifies not only the *linguistic cliches* of the emergent totalitarianisms, but also the crimes and misdemeanours of the *audio-visual language* of the MASS MEDIA and, in particular, those of this *denunciatory telesurveillance* we see being installed all over the world.

While psychoanalytical culture managed to bring artists up to speed with tales from the FREUDIAN DIVAN, twentieth-century political culture would embark on the rocky road of trying to control the silent majorities. TO MAKE SOMEONE TALK would suddenly become a major requirement with the advent of the poll and television ratings systems.

The imperatives of *state security* and those of *advertising* become indistinguishable in identifying trends in public opinion. And so contemporary art finds itself dragged kicking and screaming into this escalation in the use of investigative and promotional campaigns, especially in the United States, where sponsorship turns into manipulation, pure and simple. That is, until the Saatchi affair of autumn 1999, when the exhibition 'Sensation' at the Brooklyn Museum, financed by *Christie's International* had the unavowed aim of speculating on the value of the works on show.[11]

Despite Magritte and a handful of others, commercial imagery – *verbal art, visual art* – would wreak the havoc we are all too familiar with yet which has for some reason provoked less of an outcry than that wreaked by 'Socialist Realism', the official art of the defunct Soviet Union . . . The *comic strip* iconography of the likes of Roy Lichtenstein taking on the noisy sound effects of the Futurist machines, Mimmo Rotella apeing systematic billposting, etc. Why go on?

As for Andy Warhol, listen to him: '*The reason I'm painting this way is because I want to be a machine.*'[12]

Like Hamlet reinterpreted by the East German defector Heine Müller, the WARHOL-MACHINE no longer has something to say about the 'worker', but only about the 'unemployed'.

Somewhere between Antonin Artaud and Stelarc, the Australian *body artist*, Warhol does not so much document *the end of art* – preceding the end of history – as the end of the man of art: *he who speaks even as he remains silent.*

Whether what is at issue is the manual speech of the painter or the bodily speech of the mime artist or dancer, we are now living in the age of suspicion with doubt about the creative faculties of naked man holding sway.

With *the indictment of silence*, contemporary art can't quite shake off the acccusation of passivity, indeed, of pointlessness . . . The case instituted

against silence, citing the evidence of the works, then ends in out and out condemnation of that *profane piety* that was still an extension of the piety of bygone sacred art.

Silence suddenly stops being indulged: he who says nothing is deemed to consent *in spite of himself to* judgement of the artist on mere intention.

Accused of congenital weakness, the silence of forms and figures suddenly turns into MUTISM: the mutism of abstraction or that of an indeterminate figurative art whose victims were to be Giacometti, Bacon and co.

'The less you think, the more you talk', Montesquieu pointed out. Surely the same thing applies to the visual arts. *The more you talk, the less you paint!*

The first thing to go was craftsmanship, a victim of industrial manufacturing from the eighteenth century onwards. In the twentieth century, it was art's turn to feel the impact of industrial repetition – head-on.

Victims of an art that claimed it contained all the others, with television following hot on the heels of the movies, the visual arts have slowly vanished from the set of history and this despite the unprecedented proliferation of museum projects.

The art of the motor – cinematographic, video-computer graphic – has finally torpedoed the lack of MOTORIZATION of the 'primary arts'. And I don't just mean the oceanographic arts or those that have come to light at Thule in Greenland but also, equally, *the gesture of the artist* who, first and foremost, brought his body with him: *habeas corpus*; all those corporal arts whose vestiges remain the actor and the dancer. Such motorization thus prefigures the disastrous virtualization of choreography, the grotesque dance of clones and avatars, the incorporeal saraband of some *choreographic* CYBER-ABSTRACTION which will be to dance what the encoding of *digital* HYPER-ABSTRACTION has already been to easel painting.

The Nazi assault on *degenerate art* would thus be followed by the age of *computer-generated art*, AUTOMATIC ART, cleansed of any presence *sui generis* – an aesthetic cleansing thereby perpetuating the recent ethnic and ethic cleansing in the theatre of the Balkans.

And so, after the SACRED ART of the age of divine right *monarchy* and after the contemporary PROFANE ART of the age of *democracy* we will look on helplessly, or just about, as a PROFANED ART emerges in the image of the annihilated corpses of *tyranny*, anticipating the imminent cultural accident – the imposition of some multimedia 'official art'.

Art breakdown, contemporary with the damage done by technoscientific progress. If 'modern art' has been synonymous with the INDUSTRIAL

revolution, 'postmodern art' is in effect contemporary with the INFORMATION revolution – that is, with the replacement of analogue languages by digital: the computation of sensations, whether visual, auditory, tactile or olfactory, *by software. In other words: through a computer filter.*

After the like, the ANALOGOUS, the age of the 'likely' – CLONE or AVATAR – has arrived, the industrial *standardization* of products manufactured in series combining with the standardization of sensations and emotions as a prelude to the development of cybernetics, with its attendant computer *synchronization*, the end product of which will be the virtual CYBERWORLD.[13]

It might be useful to note, by way of winding up these few words, that the hypothesis of *an accident in AESTHETIC values* – or in scientific knowledge – in the age of the information revolution is no more farfetched than the hypothesis of the *accident in ETHIC values* that shook Europe in the age of the production revolution . . .

What has recently taken place in Austria in the aftermath of the tragedy that has been playing out for ten years in the Balkans proves yet again that POLITICS, like ART, has limits, and that democratic freedom of expression stops at the edge of an abyss, on the brink of the *call to murder* – limits blithely crossed by those already going by the name of THE MEDIA OF HATE.

NOTES

Art and Fear: An Introduction

1. I would like to thank Ryan Bishop and Verena Andermatt Conley for their valuable comments on an earlier draft of this Introduction. The essays published here, 'A Pitiless Art' and 'Silence on Trial', were originally given as two talks by Paul Virilio in 1999 at the Maeght Foundation in Saint-Paul-de-Vence in the South of France. On Virilio's concept of the aesthetics of disappearance see Paul Virilio, *The Aesthetics of Disappearance*, trans. Philip Beitchman (New York: SemioText(e), 1991).

2. 'Hyperviolence and Hypersexuality: Paul Virilio Interviewed by Nicholas Zurbrugg', trans. Nicholas Zurbrugg, *Eyeline* 45 (autumn/winter, 2001), pp. 10–13.

3. *Ibid.*

4. Theodor Adorno, 'Cultural Criticism and Society', in *Prisms*, trans. Samuel and Sherry Weber (Cambridge, MA: The MIT Press, 1967), p. 34.

5. Virilio, *The Aesthetics of Disappearance*.

6. Paul Virilio, *The Art of the Motor*, trans. Julie Rose (Minneapolis: University of Minnesota Press, 1995); Paul Virilio, *The Information Bomb*, trans. Chris Turner (London/New York: Verso, 2000).

7. On Virilio's hypermodernism see John Armitage (ed.) *Paul Virilio: From Modernism to Hypermodernism and Beyond* (London: Sage, 2000).

8. The term 'banality of evil' was first coined by Hannah Arendt in Chapter 15 of her *Eichmann in Jerusalem* (London: Penguin, 1963).

9. Walter Benjamin, 'The Work of Art in the Age of Mechanical Reproduction', in *Illuminations*, trans. Harry Zohn (New York: Schocken Books, 1969), p. 242.

A Pitiless Art

1. Unpublished interview with Jacqueline Lichtenstein and Gérard Wajcman conducted by Francois Rouan, May 1997.

2. Gabriel Ringlet, *L'Evangile d'un libre-penseur: Dieu serait-il laïque?* (Paris: Albin Michel, 1998).

3. Cited in Greil Marcus, *Lipstick Traces: A Secret History of the Twentieth Century* (New York: Harvard University Press, 1990); see the chapter 'Lipstick Traces'.

Notes

4. The title of the famous conference paper delivered in Vienna in 1908 by the architect Adolf Loos.

5. Cited in Roland Jaccard, 'La Bible du Blasphème', *Le Monde*, 29 January 1999.

6. René Gimpel, *Journal d'un collectionneur, marchand de tableaux* (Paris: Calmann-Lévy, 1963), p. 292.

7. *Ibid.*, p. 291.

8. Ignacio Ramonet, *La Tyrannie de la communication* (Paris: Galilée,1999), pp. 190–91.

9. Paul Virilio, *The Information Bomb*, trans. Chris Turner (London/New York: Verso, 2000).

10. Ernst Klee, *La Médecine nazie et ses victimes* (Arles: Solin/Actes Sud, 1999), pp. 204, 342.

11. This was among the issues discussed at 'Image et Politique', a conference chaired by Paul Virilio within the forum of the 'Rencontres internationales de la photographie', Arles, 1997 (Arles: Actes Sud/AFAA, 1998).

12. Jean-Christophe Bailly, *L'Apostrophe muette: essais sur les portraits du Fayoun* (Paris: Hazan, 1998).

13. As for the curious name given to the 'Musée des arts premiers', quai Branly, Paris: are we talking NATIVE or NAIVE art here? About an art SAVANT or an art SAUVAGE?

14. Antoine de Saint-Exupéry, *Pilote de guerre* (Paris: Gallimard, 1982), p. 85.

15. See Paul Virilio, *Etudes d'impact*, on the work of Peter Klasen (Paris: Expressions contemporaines, 1999).

16. 'Art, où est ta nature?', a conference held at the Institut Heinrich Heine, Paris, 8 March 1999.

17. Axel Kahn, *Copies conformes* (Paris: Nil, 1998).

18. Ernst Klee, *op.cit.*, see the chapter 'Un généticien d'Auschwitz'.

19. *Ibid.*

20. *Ibid.*

21. A dubious account of Josef Mengele's career has recently been filmedin Germany.

22. J.-Y. Nau, 'The Lancet prend position sur le clonage humain', *Le Monde*, 15 January 1999. For the editorial quoted, see *The Lancet*, 353: 9147 (9 January 1999). The earlier editorial condemning Europe and the USA for wanting to ban human cloning appears in *The Lancet*, 351: 9097 (17 January 1998).

23. *Op.cit.*

24. See R. Boisseau in *Le Monde*, 6 March 1999.

25. Cited in Giorgio Agamben, *Ce qui reste d'Auschwitz* (Paris: Le Seuil, 1999).

26. *Ibid.*

27. *Libération*, 16 March 1999.

28. Axel Kahn, 'L'Acharnement procréatif', *Le Monde*, 16 March 1999.

29. *Libération*, 28 February 1999.

30. *Ouest-France*, 13–14 March 1999.

31. Hans Magnus Enzensberger, *Feuilletage* (Paris: Gallimard, 1998).

32. *Ibid.*

Silence on Trial

1. 'A subtractive colour process developed in Germany by Agfa AG for 16 mm film in 1936 and for 35 mm film in 1940. Agfacolor was a tripak colour process, in which three emulsion layers, each sensitive to one of the primary colours, were laid on a single base.' I. Konigsburg, *The Complete Film Dictionary*, 2nd edn (London: Bloomsbury, 1997), p. 8.

2. *The Jazz Singer*, the Hollywood film directed by Alan Crosland and starring singer Al Jolson, marks the cinematograph's entry into the age of the TALKIES, on 23 October 1927 – the date of the first public screening.

3. Patrick Vauday, 'Y a-t-il une peinture sans image?', a paper given at a seminar held by the Collège International de Philosophie, Paris, during its 1999–2000 programme.

4. Norbert Lynton, *The Story of Modern Art* (London/New York: Phaidon, 2001), p. 14, from Chapter I, 'The New Barbarians' (originally published 1980).

5. 'La BBC invente le "Murmure d'ambiance"', *Ouest-France*, 16 October 1999.

6. *Le Figaro*, 4 January 2000.

7. August Wilhelm Schlegel, *Paintings*.

8. Gustav Janouch, *Conversations With Kafka*, trans. Goronwy Rees (NewYork: New Directions, 1971), p. 160 (translation modified).

9. 'Nuit du cinéma et de la danse allemande (1910–1990)', presented by Daniel Dobbels at the Cinémathèque française, Paris, 18 January 2000. Valeska Gert is quoted by M. Fossen in the show's catalogue.

10. Norbert Lynton, *op.cit.*, p. 359, from Chapter 12, 'The Artist in Modern Society'.

11. Harry Bellet, 'Christie's, Saatchi et le musée de Brooklyn', *Le Monde*, winter 1999.

12. Andy Warhol, quoted in Norbert Lynton, *op.cit.*, p. 294.

13. 'Quite apart from the suppression of definitely heretical words, reduction of vocabulary was regarded as an end in itself, and no word that could be dispensed with was allowed to survive. Newspeak was designed not to extend but to *diminish* the range of thought, and this purpose was indirectly assisted by cutting the choice of words down to a minimum.' George Orwell, *Nineteen-Eighty-Four* (London: Penguin, 1989), p. 313 (first published 1949).

BIBLIOGRAPHY

Adorno, T. (1967), 'Cultural Criticism and Society', in *Prisms*, trans. S. Weber and S. Weber, Cambridge, MA: The MIT Press.

Arendt, H. (1963), *Eichmann in Jerusalem*, London: Penguin.

Armitage, J. (ed.) (2000), *Paul Virilio: From Modernism to Hypermodernism and Beyond*, London: Sage.

Bailly, J.-C. (1998), *L'Apostrophe muette: essais sur les portraits du Fayoun*, Paris: Hazan.

Bellet, H. (1999), 'Christie's, Saatchi et le musée de Brooklyn', *Le Monde*, winter.

Benjamin, W. (1969), 'The Work of Art in the Age of Mechanical Reproduction', in *Illuminations*, trans. H. Zohn, New York: Schocken Books.

Enzensberger, H. M. (1998), *Feuilletage*, Paris: Gallimard.

Gimpel, R. (1963), *Journal d'un collectionneur, marchand de tableaux*, Paris: Calmann-Lévy.

Jaccard, R. (1999), 'La Bible du Blasphème', *Le Monde*, 29 January.

Janouch, G. (1971), *Conversations with Kafka*, trans. G. Rees, New York: New Directions.

Kahn, A. (1998), *Copies conformes*, Paris: Nil.

Kahn, A. (1999), 'L'Acharnement procréatif', *Le Monde*, 16 March.

Klee, E. (1999), *La Médecine nazie et ses victimes*, Arles: Solin/Actes Sud.

Lynton, N. (2001), *The Story of Modern Art*, London/New York: Phaidon.

Marcus, G. (1990), *Lipstick Traces: A Secret History of the Twentieth Century*, New York: Harvard University Press.

Nail, J.-Y. (1999), '*The Lancet* prend position sur le clonage humain', *Le Monde*, 15 January.

Orwell, G. (1989), *Nineteen-Eighty-Four*, London: Penguin.

Ramonet, I. (1999), *La Tyrannie de la communication*, Paris: Galilée.

Ringlet, G. (1998), *L'Evangile d'un libre-penseur: Dieu serait-il laïque?* Paris: Albin Michel.

Saint-Exupéry, A. de (1982), *Pilote de guerre*, Paris: Gallimard.

Virilio, P. (1991), *The Aesthetics of Disappearance*, trans. P. Beitchman, New York: SemioText(e).

Virilio, P. (1995), *The Art of the Motor*, trans. J. Rose, Minneapolis: University of Minnesota Press.

Virilio, P. (1999), *Etudes d'impact*, Paris: Expressions Contemporaines.

Virilio, P. (2000), *The Information Bomb*, trans. C. Turner, London/New York: Verso.

Zurbrugg, N. (2001), 'Hyperviolence and Hypersexuality: Paul Virilio Interviewed by Nicholas Zurbrugg', trans. N. Zurbrugg, *Eyeline*, 45 (autumn/winter), pp. 10–13.

PART TWO
ART AS FAR AS THE EYE CAN SEE

ACKNOWLEDGEMENTS

The translating of this work has been an exercise in 'the aesthetics of disappearance' of a painfully particular kind. The present published translation is a phoenix rising from the ashes of technological meltdown. If the bird doesn't fly as swiftly as it might, or its bite is not as sharp as the original, then we can safely blame 'the original accident' – and the translator. For their overwhelming support, I must thank some very wonderful people: my editor at Berg, Tristan Palmer, and the whole Berg team, Joanna Delorme at Galilée, and Paul Virilio, who is as generous a friend as he is constant and true.

A more personally painful disappearance occurred as I was completing the redraft in late December 2006. And I would like to offer up this translation to Anita Joan Armfield, known to all as Nita, as well as to Esmé Ada Woodley and Marie Madeleine Rose, all three my cherished departed mothers.

To give that phoenix, Cleopatra, the last word: 'I am fire and air; my other elements I give to baser life.'

Julie Rose

CHAPTER 1
EXPECT THE UNEXPECTED

The seventeenth century was the century of mathematics, the eighteenth, of the physical sciences, and the nineteenth, of biology. *The twentieth century is the century of fear.* You'll tell me that fear is not a science. But science has had a hand in it from the outset, since its latest theoretical advances have lead it to cancel itself out and since its practical improvements threaten the entire Earth with destruction. What's more, if fear in itself cannot be considered a science, there can be no doubt whatsoever that it is a technique.[1]

So wrote Albert Camus in 1948. I would add that, since that date, fear has become a dominant culture, if not an *art* – an art contemporary with mutually assured destruction.

Since the eighteenth and nineteenth centuries, history has seen a mounting extremism (which Clausewitz studied in relation to war) but this escalation, which was to end in the balance of terror between East and West over the course of the twentieth century, has not been appreciated at its just value in relation to peace – to the peace created by deterrence that today subtends all mass media culture.

In fact, the postmodern period has seen a gradual drift away from an art once substantial, marked by architecture, music, sculpture and painting, and towards a purely accidental art that the crisis in international architecture flagged at practically the same time as the crisis in symphonic music.

This drift away from substantial art has been part and parcel of the boom in film and radio and, in particular, television, the medium that has ended up finally flattening all forms of representation, thanks to its abrupt use of presentation, whereby real time definitely outclasses the real space of major artworks, whether of literature or the visual arts.

If, according to Hegel, 'philosophy is an era put into ideas', we have to concede that the idée fixe of the twentieth century has been the acceleration of reality and not just of history.

We have seen what speed did to politics yesterday with Futurism, fascism and the turbocapitalism of the Single Market. What we are seeing now, especially, is what speed does to mass culture, since, if 'time is money', the speed of the light of the ubiquitous media means the power to move the enthralled hordes.

Having reached this point, at the very beginning of the twenty-first century, the most important political issue we face is not the Cold War and its forgotten collapse anymore, but the emergence of this cold panic of which terrorism, in all its forms, is only ever one symptom among others.

Comparable to uncontrollable terror, panic is accordingly irrational and its so often collective nature clearly indicates its propensity to turn, virtually any day, into a total social event.

Indeed, through their (often programmed) repetition, a population's disturbing panic attacks are associated with a depression often masked by the routines of everyday life. What I call 'cold panic' is thereby linked to this expectation horizon of collective anguish, in which we strive to expect the unexpected in a state of neurosis that saps all intersubjective vitality and leads to a deadly state of CIVIL DETERRENCE that is the lamentable counterpart to MILITARY DETERRENCE between nations.

'To obey with your eyes shut is the onset of panic', Maurice Merleau-Ponty had already observed in 1953. 'In this world where denial and morose passions take the place of certainties, people seek above all not to see.'[2]

Coming from the phenomenologist of perception, this observation took on significance as a warning in a period of history that deliberately engaged in a lapse of attention which lasted not for a minute but for a whole century.

With 'teleobjectivity', our eyes are thus not shut by the cathode screen alone; more than anything else we now no longer seek to see, to look around us, not even in front of us, but exclusively beyond the horizon of objective appearances. It is this fatal inattention that provokes expectation of the unexpected – a paradoxical expectation, composed at once of covetousness and anxiety, which our philosopher of the visible and the invisible called PANIC.

But this composite word covers another term contemporary with the historic period of Merleau-Ponty's inaugural discourse: DETERRENCE.

If the twentieth century is the century of fear, it is also the century of atomic deterrence, which, during the years from 1950 to 1960, established the technique of 'the balance of terror' and moved Albert Camus further to

say: 'The long dialogue between men has just ceased. A man who can't be persuaded is a frightened man.'[3]

Extending this obvious fact, the man who was to receive the Nobel Prize for literature continued:

> This is how *an immense conspiracy of silence* spread among people who already did not talk because they found it pointless, and it continues to spread, accepted by those who tremble in fear but find good reasons to hide this trembling from themselves, and encouraged by those who stand to gain from it. '*You must not talk about the purge of artists in Russia because that would benefit the reactionaries*' . . . I said fear was a technique.[4]

And this is how, midway through a pitiless century, the technique of panic lead to the art of deterrence – not only strategic deterrence between East and West in a world threatened with extinction, but also political and cultural deterrence. This 'world in which denial and morose passions take the place of certainties', which certain self-righteous conformists, chiming in with Sartre, were to call 'engagement' or 'commitment'. The world of contemporary art, which was soon to drift, in turn, from 'social realism' towards 'pop culture' and the realism of an art market that still dominates these early years of the twenty-first century.

Basically, it all began when painters relinquished the study of the subject and went back inside their studios in a re-run of the age of academic classicism.

With Impressionism or, more exactly, after the Great War, modern art was dragged down into the panic that struck Expressionist Europe and saw the emergence of Surrealism, hot on the heels of Dadaism. We can extend this foretaste of disaster, furthermore, to European philosophy, with the discrediting of phenomenology, the disappearance of Husserl and the resounding success of Existentialism, in that period of transition that kicked off between the two world wars and found its consecration in the 1950s just evoked, with the end of the dialogue between men and, especially, with forgetting: that loss of empathy not only in relation to others, but in relation to a human environment turned into a desert through the annihilation brought about by the air raids that, from Guernica to Hiroshima, via Coventry, Dresden and Nagasaki, have blurred our view of the world, that perception DE VISU – with our own eyes – which subtended the whole of Western culture for 2,000 years.

But, apart from the 'aeropolitics' of a mass extermination of cities, which was to put paid to continental geopolitics – the retinal detachment of a culture that already anticipated the economic deterritorialization of internationalization – we should also note how, from the nineteenth century on, the progress in popular astronomy so dear to Camille Flammarion ushered in the sudden multiplication of the telescopes that were to foreshadow the shift in viewpoint occasioned by the boom in domestic television, itself favoured, over the twentieth century, by the launch of telecommunication satellites.

To see without going there to see. To perceive without really being there . . . All this was to shatter the whole set of the different phenomena involved in visual and theatrical representation, right up to representative democracy, itself threatened by the broadcasting tools that were to shape the standardized democracy of public opinion as a prelude to landing us in the synchronized democracy of public emotion that was to ruin the fragile balance of societies supposedly emancipated from real presence.

In a world based on denial and general deterrence, where one now seeks less to see than to be seen by all at the same instant, whenever we refer to transhorizon 'Large-Scale Optics', we immediately invoke transpolitical 'Large-Scale Panic' in the face of the acceleration of a common reality that not only outstrips us in tyrannical fashion, but literally outpaces all objective evaluation and thereby all understanding.

A morgue assistant named Maurizio Cattelan, who calls himself 'an accidental artist', once declared: 'I handled dead people and I saw their distance, their impenetrable deafness. A lot of what I've done since then comes from that distance.'[5]

After the issue of instantaneity's lack of delay, here we have the issue of ubiquity's distance, only the perspective is reversed: what now counts is not the vanishing point in the real space of a scene or a landscape, but only vanishing in the face of death and its question mark – its interrogation point – in a perspective of real time used and abused by the cathode screen with live broadcasting, offering 'death live' and an endless funeral procession of repeat disasters.

So, after abstraction, the monochromatism of, say, Yves Klein and the advent of an imageless painting,[6] when nothing more can get to us, really touch us, you no longer expect some brainwave of genius, the surprise of originality, but merely the accident, the catastrophe of finality. Whence the secret influence of terrorism, following on from (German) Expressionism or (Viennese) Actionism, as though Jerome Bosch and Goya endorsed the debauchery of crime.

Note, on this score, that the furiously contested show staged at the beginning of the year 2005 in the Kunst-Werke, Berlin's Institute of Contemporary Art, with the title 'Regarding Terror: The RAF. Exhibition', based its underlying concept, which was aimed at denouncing the so-called myth of the Rote Armee Fraktion, the Red Army Faction (RAF), on the works of three generations of artists, including Joseph Beuys, Sigmar Polke, Gerhard Richter, Martin Klippen Berger and Hans Peter Feldman, whose danse macabre aligns the names, faces and bodies of terrorists, but also of their victims, in a strange process that singularly recalls the looping of televised sequences.

In fact, the 'redemptive suffering' of contemporary art arises from profanation not of the sacred art of our origins anymore but of the profane art of modernity, that (critical) moment when re-presentation gives way to the lyrical illusion of presentation, pure and simple. When 'art for art's sake' bows down before the TOTAL ART of multi-media teleobjectivity that takes over from the artifices of the seventh (cinematographic) art, which already claimed to contain all six others.

This is it, the obscenity of ubiquity whereby 'postmodern' academicism outdoes all the avant-gardes put together, with the exception of the particular avant-garde of mass terrorism, whose advent the television series brings to the light of day, in the place and space of the action of antique tragedy.

Here a parallel suggests itself between the atheism of postmodernity that sets out 'to replace what it destroys and begins by destroying what it replaces',[7] in a sort of lay deicide, and the atheism of the profanation of modern art to the exclusive advantage of a cult of replacement that has all the characteristics of illuminism – not the illuminism of the encyclopaedic revolution of the Enlightenment now, but the illuminism of a multi-media revelation that exterminates all representative reflection in favour of a panic reflex on the part of an individual whose relativism (ethical and aesthetic) suddenly disappears in the face of this virtualism that acts as a surrogate for the actual world of facts and established events.

If, today, theologians talk about an 'atheism that even strives to do away with the problem that caused God to be born in our consciences in the first place',[8] critics of contemporary art toss around the notion of an 'anthropotheism' that would even do away with the origins of modern art, of its free expression, which is no longer figurative now as once upon a time but graphic and pictorial (whence the iconoclastic ban on paintings in a number of art galleries).

At the end of the last century, Karol Wojtyla, better known as Pope John Paul II, declared: 'The problem for the Universal Church is knowing how to

make itself visible.' At the start of the third millennium, this is the problem of all representation.

'We are everywhere you look. All the time and everywhere in the world.' This advertising slogan of Corbis, the agency founded in 1989 by Bill Gates with the avowed aim of monopolizing the photographic image, illustrates the large-scale panic that has beset representation in the age of scopic expansion.

If, for some, the aim is thus to see everything and also to have everything, for the anonymous hordes it is solely to be seen.

When you know that the Internet image provider brings together the photographic archives of the world's most prestigious museums, you can get some idea how important their realtime presentation now is and how much they discreetly discredit the works themselves – the real ones!

What was still only on the drawing board with the industrial reproduction of images analysed by Walter Benjamin, literally explodes with the 'Large-Scale Optics' of cameras on the Internet, since telesurveillance extends to telesurveillance of art.

Faced with this acceleration of reality, the new telescope no longer so much observes the expansion of the universe – the Big Bang and its distant nebulae – as the down-to-earth break-up of the sphere of perceptible appearances that are disclosed in the very instant of looking.

This is it, the multimedia REVELATION that surpasses the encyclo-paedic REVOLUTION of the Enlightenment; this is it, the 'illuminism' of telecommunications that suppresses the pictorial icon – but also the crucial importance of the glimpse de visu and in situ, to the exclusive advantage of live coverage of the perceptive field.

'In a digitized world, we offer creative visual solutions. The objective for us is to give a message the strongest impact,'[9] says Steve Davis, the president and CEO of Corbis.

From this, we can more easily see through the recourse of visual/audio-visual creation to the looping of panic-inducing segments of terrorism or of natural or industrial disasters – this replay that television stations now systematically abuse, this combat sport that does battle with the apathy of televiewers who expect the unexpected alone to wake them out of their leth-argy a little, out of the attention deficit that has replaced vigilance in them and, especially, all practical interest in whatever crops up in their imme-diate proximity. How can we be astonished or ultimately even scandalized by aggressiveness, by a violence that has now become customary at every level of society, when empathy, the twin sister of sympathy for others, has

disappeared from view at the same time as the phenomenology of which it was the heavy crux?

Too impressionist, no doubt, not actionist enough, perhaps? Once empathy goes, the 'reality show' replaces dance and theatre.

In the beginning, the term 'empathy' had the primary sense of 'touching' and referred to physical contact with tangible objects. With Edmund Husserl, it would come to denote the effort to perceive and seize the reality that surrounds us in all its phenomena, in all the forms in which that reality manifests itself. Whence the importance, at the beginning of the twentieth century, of Wilhelm Worringer's key work: *Abstraktion und Einfühling* (1907), translated as *Abstraction and Empathy: A Contribution to the Psychology of Style*.

We can apprehend to what extent teleobjectivity has today made us lose our grip, the immediate tact and contact that not only promoted the customary civility but also all actual 'civilization', thereby enhancing the impact of a growing terror – this terror that can strike us dumb every bit as much as blind. A survivor of the 1943 bombing of Hamburg acknowledged its effects: 'It was my initiation into the knowledge that looking means suffering; so after that, I could no more stand looking than being looked at.'[10]

This is it, this eyes-wide-shut panic signalled by Merleau-Ponty at the start of the age of Large-Scale Deterrence!

But at the very start of the new millennium where the performance of instantaneous communication outclasses the substance of the oeuvre, of each and every oeuvre – pictorial, theatrical, musical – and where the analogy disappears in the face of the feats of digitization, Large-Scale Panic is panic induced by an art contemporary with the disaster in performances, the misdeeds of a telescopic perception where the instrumental image drives away our last mental images, one after the other.

Merleau-Ponty further wrote: 'Nature is an enigmatic object, an object that is not absolutely an object; it is not absolutely in front of us. It is our ground, not what is in front of us, but what bears us.'[11]

By dint of looking in front of us, at eye level, we have ended up inventing the accident of the telescope, of all the telescopes, from Galileo's glass to the widespread telesurveillance that now exiles us beyond appearances in the transappearance of a far away that eliminates the near – whether it be the nearby tangible object or a nearby painting, even a self-portrait of one's fellow, one's like, favouring instead the plausible, the likely, and its virtuality.

Today we have no option, not to shut our eyes, but to lower them – not out of timidity but, on the contrary, out of courage in order to look steadily,

not at the End of History, but at this 'support-surface' whose down-to-earth limit is visibly below us, in the HUMUS of a statics that has borne us from the beginning of time.

'The Earth does not move', warned Edmund Husserl at the end of his life. This is it, this reversal of viewpoint of Galilean space: this ground, this floor of the great vehicle formed by a star that can no longer bear the acceleration of the real and so pits its fixity and its telluric resistance against the vanishing point of a horizon from now on doubly buckled.

This phenomenological paradox partly explains the recent geopolitical and strategic upheavals, but every bit as much, it would seem, those involved in the 'reality show' of an art contemporary with the foreclosure of the planet. There is a sort of return here of what was trampled and buried underfoot! Not the return to the Mother Earth of our pantheist origins but the return of an earthling's empathy with the enigmatic object our philosopher of perception so rightly talked about in relation to a Nature that not only surrounds us on all sides but has so long inhabited us.

'I am not moving around. Whether I am sitting still or walking, my flesh is the centre and I am grounded on ground that does not move', wrote Husserl. He concluded: 'For as long as the Earth itself is actually a ground and not "a body", the original ark, EARTH, does not move.'[12]

However, the question of its (spatio-temporal) finiteness changes the nature of the original ground, since the end of extension poses in return the question of its fixity, of its inertia in relation to the world of the living who are moving around on the spot.

Not long ago my flesh as an earthling seemed, indeed, to be the unique centre of the living present Husserl is talking about, but since the acceleration of reality in the age of temporal compression, this carnal centre of presence extends to the TELEPRESENCE in the real-time world delivered by the instantaneity of a ubiquity that has now gone global.

Here, the 'dromoscopy' – the optical illusion experienced by the motorist whereby what stays still appears to recede while the interior of the moving vehicle appears stationary – taints representation of the whole world, not just the roadside.

We suddenly jump from real-space objectivity de visu and in situ to the real-time teleobjectivity of an acceleration whereby the spaces of perception, the optical space and the haptic space of the tangible, undergo a disturbance – a topological or, more precisely, a TOPOSCOPICAL disaster.

What illusion are we actually talking about when one's body proper is identified with the world proper? And, in particular, what is the impact on

the egocentricity involved in this MEGALOMANIA that has struck not just a few disturbed individuals but the whole of the living gathered in front of their screens?

Within this logic of the great lockdown, where inside and outside merge, the world is not only the gigantic phantom limb of humanity, but also means hypertrophy of the ego, a sort of INTROPATHY that then takes over from mutual SYMPATHY.

We might recall what Maurice Blanchot had to say on the carceral policy of the eighteenth century: 'To shut up the outside, to set it up as an expected or exceptional interiority, such is the requirement that needs to be in place for madness to be made to exist – meaning, for it to be made visible.'[13]

What can we say of INTROPATHY, at this early stage of the twenty-first century, except that it makes visible the general spread of the megalomania involved in real time along with its inertia?

'Is there a privileged Here? Yes, absolute zero energy', Husserl announced in 1934.

'Seeing that it is the most comfortable, the reclining position ought to be the zero position', the German phenomenonologist concluded, thereby introducing, after the seated woman, the age of reclining man.

So this is it, this finiteness of the 'action quantum' whereby the inertia of the star that bears us becomes the inertia of the animated being – that political animal whose vitality, once celebrated by the Greeks, today buckles before the comfort of zero energy in a man who is not even a true spectator any more, but the author of a domestic virtuality on a life-size scale.

Paraphrasing Karl Kraus on the subject of PSYCHOANALYSIS, only this time apropos the TOPO-ANALYSIS of globalization, we could say that it is the symptom of a disease that claims to be its own therapy!

'I, the horizon, will fight for victory for I am the invisible that cannot disappear. I am the ocean wave. Open the sluice gates so I can rush in and overrun everything!'[14] For those of us who live in the twenty-first century, Apollinaire's prophecy came to pass a long time ago already.

Since the wave of electromagnetic fields flooded the earth with audio-visuality, not only has the skyline been locked down in the rectangle of the screen, of all the screens, but the spectator has now morphed into a tele-viewer who stretches out or, rather, lies down in front of it.

In bygone days, they used to describe painting and the picture that resulted as an 'open window' . . . What remains of this optical metaphor?

For instance, what is the teletopology of a building under telesurveillance in which, from each abode, you can watch all the others; in which, more

precisely, each of the rooms of the sundry apartments functions like a video control unit, monitoring the whole set of the others?

Even more crucially, what teleobjective worldliness are we dealing with when the same thing goes for each of the five continents, for the towns that people them and for their innumerable buildings covered in antennae?

If, according to Plato, the sophism of the painter consisted in only showing his 'mirage' at a distance, what mirage are we dealing with today, with the real-time televising of the world?

Having worked in the past with a number of painters and stained glass makers, I always felt that the Gothic opening of the great rose windows of cathedrals was less an opening on the sky than an opening on the light of the beyond up above. With the trans-appearance produced by electromagnetism, teleobjective illuminism, on the other hand, no longer opens on anything but the here below.

Miserable miracle of a MEGALOSCOPY whereby the latest telescopes are no longer turned on the night sky now but on the satellite belt, the endless day of 'real time'.

Here, the EGOCENTRICITY of the human being's body proper is transferred to the inertia of the earthling's world proper – in other words, to peripheral EXOCENTRICITY – for this man of the Last Day who is now no more than a fully fledged sedentary being, a lounge lizard, driven by his megalomania to revise more than to revisit his cramped domain, in an ambulatory dementia in which accelerated displacement doesn't even mean a journey any more, but a vibration analogous to that of the waves that convey his telescopic sensations . . .

To wrap up these comments, we might now observe that if the discovery of the (animated) cinematographic image was indeed contemporary with the first great wave of transatlantic migration, since that time the transport revolution has gone supersonic and the (televisual) videographic image has reached its peak shortly after aeronautics reached and broke the sound barrier.

Once that happened, thanks to supersonic rocket propulsion, it was no longer the heat barrier that was broken. The light barrier had become the ultimate objective of our view of the world.

In this sudden transmutation of aesthetics, we can better glimpse the reasons for iconoclasm, the programmed demise of the fixed image offered by paintings now banned from being hung, and the infatuation of art for art's sake with performance, along with all the installations of every stripe that

systematically clutter gallery and museum spaces. Similarly, we can better understand the persistence of a kind of sculpture whose inertia and statics have become emblematic of this sedentary being, a lounge lizard, this universal bedridden invalid, contemporary with the MEGALOSCOPIC age. We can also understand the historical importance of land art when, in the twentieth century, landscape is displayed on film, in the freeze frame – a photo-finish in which the photographic shot is now scarcely more than the proximity of a frozen sequence: that of instantaneity.

As in the panic evoked above, with the photographic sequence looking means suffering the irremediable, the dread involved in a fixation whose inertia is illustrated even more clearly by the looping of televised sequences. This is not just the inertia of the fixed image of bygone days, but that of the animated image, looped back on itself, as was the revolving stage of the panoramas of yore, as is the MEGALOSCOPY of the parabolic antennae of today, hooked up as they are to the endlessly revolving broadcast satellites of 'world vision' . . .

Strangely, cutting-edge aeronautics has taken the same turn, since certain prototypes, like Voyager not so long ago or Global Flyer today, seem bent on turning into low-orbit satellites, performing round-the-world flights with no stops and with no refuelling.

Figures of a tourist itineracy in the end as derisory as that involved in the postural inertia of reclining man, riveted to his screens, or that of those traders in quest of surplus values whose supplies of capital whiz round the Earth several times in the one day before filling the coffers of the stock-exchange casino.

Fatal signs of a planetary foreclosure, these new fairground merry-go-rounds could well bring out a boredom of the third kind, that close encounter involving contact, following the boredom induced by close encounter with the television series: no longer the boredom once produced by uniformity but the boredom that will be produced tomorrow by circularity (circum terrestre).

'Escape for thy life, look not behind thee, neither stay thou in all the plain!' warned the emissary from Heaven. But Lot's wife 'looked back from behind him and she became a pillar of salt'.[15]

A Biblical symbol, the tale of the annihilation of Sodom emphasizes, at one and the same time, the turning away from morals and the turning back of the observer of the disaster. Something analogous is at work today, it would seem, before our very eyes, in this turning to ice whereby accelerated cathode reality results in a trans-appearance that not only penetrates the

horizon of perceptible appearances but the flesh of denuded bodies or, further still, those materials whose opacity once obstructed the eyes' cupidity.

Whether the philosopher of the eternal return, Nietzsche, likes it or not, it is no longer the growth of the desert that awaits us, but its impassability, its turning into a closed circuit. Characteristic of this celestial closure is the land art of James Turrell, pilot emeritus whose tourist plane became a studio, a flying studio, not unlike the folding easel Van Gogh took with him on the road to Arles, and which has served him 'to return to the subject', in Desert Paints, exploring a habitable crater . . .

But, to conclude, let's get back to that specific panic evoked by our philosopher of perception in 1953. At the Poitiers Futuroscope theme park, in 2005, a new attraction was launched. It was called: 'Eyes Wide Shut'.

And so, half a century after Merleau-Ponty's caution, futurism has abruptly transformed itself, for, at the Poitiers site, the experience proposed is no longer bound up with new image technologies, as in the recent past. It is an experience of voluntary blindness.

In a light-proof building, visitors gather in groups of ten for a guided tour led by one of the sightless; as in Breughel's painting, *The Blindman and the Paralytic*, everyone has to hang on to the shoulder of the person in front. During this initiatory trip into the heart of darkness the visitor passes through three different ambiences in succession: swamp, city, beach. As for the guide's message, it goes like this: 'Don't hesitate to touch!' . . . thereby indicating to all and sundry that for them, from now on, sight and touch are the same thing. As one of the officials in charge of the Poitiers image park puts it: 'By coming here, people give themselves a challenge, for in this course roles are reversed, social barriers drop and you get a better understanding of what blind people feel.'[16]

TELESCOPE, MICROSCOPE, FUTUROSCOPE, Galileo's long sight results in the blindness involved in a bout of role-playing in which everyone carries a handicap.

They don't want to see, they want to be seen, we wrote previously. By way of confirmation of this reversal of perspective provoked by cathodic tele-objectivity, note that the FUTUROSCOPE will also open a second 'flagship attraction', called 'Stars of the Future', with the aim of showing the ambience on the set during a television shoot to visitors suddenly transformed into actors, alongside real actors, people working in the performing arts, who will help give them a taste of the joys and the sensations of telereality.

CHAPTER 2
AN EXORBITANT ART

Has aeronautics become an aesthetics and aviation an art, as Santos-Dumont hoped? Certainly not, but it has most definitely become a performance, a feat of levitation Leonardo da Vinci long dreamed of.

In the beginning, the aeroplane was not just one means of transport among others, but an observation tool for seeing the surface of the world from on high; an altimetric distancing device designed to dominate the Earth at a single glance, and the surest means, after the tower, of seeing not only from a long way away, as with longsightedness or the telescope, but from high up.

On this subject, let's hear it from painter-cum-writer, Marek Halter: 'Pollock understood that America was not just an extension of Europe, that America was vast and that this ought to be felt in painting.' Struck by this height in vantage point, which had less to do with pictorial technique than with the new-fangled aeronautical technology of the Wright Brothers, Halter goes on: 'Pollock is the first painter to abandon the easel and place the canvas on the ground in order to take in the painting from above. It's like a landscape seen from a plane. European paintings are landscapes seen from the window of a train.'[1]

You notice how, here, the vehicle is the determining factor in distinguishing the avant-garde nature of the art of painting: the train and its (dromosopic) cinematics, the aeroplane and its (altimetric) statics.

For the Old Continent, the outlook is on the horizon and its railroad perspective; for the New World, the outlook is on the NADIR starting from the aerial zenith – that abstract world of aeroscopy celebrated by Nadar that, at the close of the twentieth century, would end in the televisual MEGALOSCOPY referred to above.

But, here, the artistic achievement of Jackson Pollock and a whole host of others, is a scopic turning back to face the terrestrial surface. Instead of observing the line that decides between Earth and sky, you observe the surface, the 'support-surface', as people once contemplated the stars in the age of popular astronomy. This has reached the point where the AERODROME of

teledetection by observation satellite will soon prevail over the gaze turned on infinity of an ASTRONOMY on which the whole panoply of our civilizations once depended, though.[2]

If we are to believe Marek Halter, the SUR-VISUALISM of abstraction took over – in the United States, at least – from the SUR-REALISM of the Old Continent, as a prelude to the incontinent TELEVISUALISM of a world buckled in on itself, in this 'real-time perspective' of ubiquity that gives the real-space perspective of the Quattrocentro its stereoscopic 'relief'.

This is it, the doping whereby artistic activity, like economic activity, bites the dust wherever excess wins out over the essay and wherever the sporting absurdity of some record or other takes over from the experiment of genius. After Amerigo Vespucci's Italy, America, like Africa, was off to a bad start or, more precisely, it fell from a great height, for it is no longer a matter of some renaissance, but of a brutal return to Earth, to Earth's plenary substance . . .

Here, the accident in art, like the accident in a science devoid of a conscience, is its very success, its ex-centric prowess that drives it to insignificance.

And so the art for art's sake of a disunited Europe was overtaken, in the immediate postwar years, by the performance for performance's sake of American DRIPPING PAINT (Action Painting) à la Pollock, anticipating, for the end of the century, the eternal return of an orbital circulation whereby aero- and astro-nautics were to merge in a 'mannerism' that no longer speaks its name.

To fly or to overfly? To swim or to float? To live or to survive? Mermoz rejected the last option when he declared, just before disappearing: 'I wouldn't want to be a survivor.'

Yet that is the fate of an art contemporary with the aesthetics of (geospherical) finiteness where the progress of exhibitionism is too often pegged to the requirements of the market, with its competitive practices that have nothing to do with the advancement of knowledge, but solely with that of a closed-circuit parlour game where the spectacle of the unexpected has supplanted the spectacle of 'beauty'.

To stay in the realm of sport, we might take the example of the famous ocean liner, the Titanic, which sank on a certain night in 1912 not so much because of a navigation error, as has been claimed, but indeed because its course via the North Atlantic was supposed to allow it to win the 'Blue Ribbon' and so compelled it, despite the lack of visibility, to go full steam ahead at any cost.

According to White Star, the company that owned it, the ship did not swim; it floated before sinking without a trace. The titanic ocean liner did not pass via the North Atlantic; above all, it had to surpass its rivals from the Cunard Line.

The fatal accident of the shipwreck was thus not so much that of a supposedly 'unsinkable' ship as an accident in a competitive performance where the progress of excess speed no longer had anything in common with the progress of the in-flight test of pioneers like Montgolfier in aerostation or the Wrights in aeronautics.

After the ship, let's take the example of the aeroplane, also described as 'heavier than air'; to be more precise, let's take the example of Alberto Santos-Dumont's plane, DEMOISELLE.

Gazing at this plane some little time ago at an exhibition on the Champs-Elysées, it was all too obvious that this flying art object was indeed destined to fly, along the lines of the blue dragonfly it was named after, whereas the supersonic fighter planes and other supersonic 'combat jets' that surrounded it were destined to over-fly, to punch through the depths of the heavens, their performance as piloted missiles outdoing aeronautics, just as that of the ocean liner, the Titanic, tried to outdistance the nautical dimension of its transatlantic crossing.

'You can't stop progress . . .', they say. Sure, but what progress? The progress in the substance of the motor or the progress in the accident in its performance? A sporting performance whose reward is, if not a ribbon, then a medal, but more especially the operating earnings, a profit, that result from the doping of these arts et métiers that once practised experimental research – not the extreme sports of technoscience.

Synonymous with overkill, technological progress more than ever poses the question of reasoned choice between qualitative and quantitative.

To stay in the area that concerns us, note that since aviation turned, if not into an 'art' then at least into a 'dominant culture' with the orbital aeropolitics of globalization, the launch of the Concorde has been followed by the launch of the Airbus 380, the biggest airliner ever built, unveiled in an epic ceremony entitled 'REVEAL', which brought four European heads of state – British Prime Minister Tony Blair, French Prime Minister Jacques Chirac, German Chancellor Gerhard Schröder and Spanish Prime Minister Jose Luis Rodriguez Zapatero – together in Toulouse at the Jean-Luc Lagardère Final Assembly Line, on 18 January 2005.

After the case argued for supersonic and shortly hypersonic speed, according to the words of the prophets of a happiness suspended from

the pods of reactors, comes the case argued for the maximum carrying capacity of a 'superjumbo' jet capable of carrying over 800 passengers. Here again, what progress are we talking about if not progress in purely quantitative excess?

Along the lines of Boeing's Jumbo jet, the Airbus will not exceed the hypersonic limits initially provided for the Concorde's successor; it will merely put in the air, at the same time, in one and the same aircraft, close to a thousand people . . .

If this is real progress in the transcontinental aeroplane, it is also progress in the major risk of causing a whole mass of passengers to perish, swiftly, in one and the same crash.

Is the goal of civil aeronautics, in fact, to put everyone in the air, as the advocates of the FLYING NATION of the totalitarian regimes of the 1930s already hoped to do?[3]

Are we dealing with some kind of economic progress that would facilitate the democratization of air transport, a progress necessarily shared by all, at the same time, as a slogan of the SNCF, France's national railway company, claims?

Let's nudge technoscientific outrageousness along: if tomorrow or the day after, they once more send up gigantic dirigible balloons capable of carrying thousands of passengers at reduced fares, which it seems is on the cards, will this be about the future of aeronautics or its past?

Aware of the obesity of the 'superjumbo', humorists at the Toulouse shindig noted that all that was missing was a swimming pool and a tennis court . . . But let's be serious! If the fact of navigating the seas and oceans represented certain progress for the earthlings that we are, if flying over the top of the clouds meant even greater progress, the excess involved in the performance of this new type of displacement has nothing whatever to do with progress because the Earth is a limit not only due to its reduced size but also due to its composite telluric nature.

Two kinds of accident confront us today: the accident in the essay, the test, one that happens in the discovery of a substance, noxious or otherwise, or the invention of some technical object or other, useful or otherwise; and the accident in excess of all kinds – the sporting, not to say, Olympic, quest for record results at any cost, including the lives of innocent victims.

These expressionist practices are linked to the doping of the 'top level' champion, in which the progress in excess is merely a mass killing analogous, in the end, to the desperate quest for 'mutual destruction' on the part of military men of all stripes. In these conditions, the extreme sport of

technoscientific progress would scarcely amount to anything more than an agreed human sacrifice, at least for some time to come yet.

Born the same year as the Lumière Brothers' cinematograph, aviation has little by little turned into a sort of large-scale circus where the breaking of the famous sound barrier foreshadowed the propulsion that was to allow rockets shortly after to exceed escape velocity, thereby anticipating the 'illuminism' of a large-scale televisual optics that, for its part, would put to work the speed of light.

After Alberto Santos-Dumont, aviation's poet, and Charles Lindburgh, its trans-Atlantic prophet, we have the American engineer, Burt Rutan, who is now leading the race around the world with his Global Flyer, which, as it happens, has just 'looped the loop' in under 80 hours – 67 hours, to be precise – something Jules Verne would never in his wildest dreams have hoped to achieve.

Walk One for a single man, in the event Steve Fosset, unbeatable all-round champion of a CIRCUM TERRESTRIAL DERBY, who executes his closed circuit in the manner of a thoroughbred on the hippodrome, thereby transforming the low orbit of his manned flight into a HOMODROME.

To conquer at any cost the reserve of resistance to advancement: that offered by the too-long duration of distances (aerostatics) every bit as much as by the toughness of materials (their statics), that's what it's all about! From now on, that is the objective of the all-out record achievements of the excess in progress.

After astronomic telescopy and televisual videoscopy, the aeroscopy of our view of the world has tipped the gaze of each and every one of us inwards towards the centre of the Earth, while we wait for the unending round of spy satellites in turn to exercise the navel-gazing we are now so familiar with, in practising the most extreme police telesurveillance.

And so, the extraverted perspective of real space, which was the perspective of the art of painting of the Quattrocento, has been overtaken by the introverted perspective of this real time that provokes the 'relief' of the occurrence of the world. But this relief lacks a third dimension and owes everything to the fourth dimension and to the intermediary of the instantaneity of telecommunications.

After the highs and lows of stereophonic high fidelity, the time is now upon us of a stereoscopy in which the actual and the virtual replace left as well as right, high as well as low . . .

Faced with this sudden disorientation, how can we still be amazed at the profanation not only of art, but also of a politics of nations that advertising

has thoroughly exploited, leaving its traces, as it has done, from Magritte right up to Warhol and Saatchi, to say nothing of the role of the spin doctor, that complicit and all-too-often complacent agent in the governing of a world from now on FORECLOSED . . .

Whereas the 'sacred art' of humanity's origins devoted itself to painting the hereafter – whence its close association with astronomy and astrology – the profaned art of the present (telepresent) time is only interested in the here-below through 'entropathical' gesticulations and contortions that demonstrate not so much its vitality as its inertia. We no longer expect anything now from art lovers turned 'art consumers' other than their passivity, their conformism. At least then we can surprise them, shake them up a bit with a spectacle that is less alive than dead-alive, in the hope of causing their reserve of resistance to boredom to crumble due to the accident of something unforeseen that tends to compensate for vision the way the unexpected suppresses expectation.

Now, after the arts of the 'modern movement' (theatre, dance, the circus, aerobatics . . .) let's move on to the arts of fixity and statics, such as sculpture, which we've talked about in relation to the inner statue of the latest sedentary human being; let's move on, then, to architecture and the resistance of the materials it uses.

A recent event, the publication of the Berthier Report, the findings of the official inquiry into the collapse, in May 2004, of Roissy Airport TERMINAL 2E in Paris, illustrates the vexed question of the too low intrinsic fatigue resistance of that building's structure.

Here again we touch on the question of the SUBSTANCE of a material (concrete) and its overall (architectonic) PERFORMANCE. Now, what is at issue here is no longer the author (the architect), or this or that precautionary principle rigorously monitored by experts, but once again the progress in excess.

In fact, what is at issue in the airport terminal's use of a concrete shell is the reserve of resistance of the load-bearing structure employed, which was gradually reduced and weakened before being cancelled out completely in a relatively short space of time.

But what are they referring to, exactly, when they talk about intrinsic fatigue resistance?

What they are referring to is the architectonic precaution that not only assures the stability of the edifice but also its durability, following the example of a long-distant past (the Roman era, for instance), where the mechanical

redundancy of building elements was, if not completely unwarranted, then at least excessive.

Today, the opposite happens. The thickness of the elements implemented is reduced to next to nothing in the name of a prowess not so much architectural as structural. In this case, as it happens, we are talking about the thickness of the concrete shells of the Roissy terminal. And not so long ago, it was a matter of the thickness of the CNIT dome in Paris' La Défense quartier. It is still a concern the whole world over, wherever you find wide-span roof coverings.

No point, then, in making this or that architectural design the scapegoat for what amounts to no more than one catastrophe among others, when responsibility for the event rests squarely with an unnatural practice that not only exhausts the planet's natural resources, but also exhausts the reserve of resistance of the diverse materials used, as though the (progressive) elimination of materiality had little by little become the primary objective of builders' engineers. This ultimately explains the current craze for transparency at any cost, the art of an architecture of light in which iron and glass take over from brick and stone, along with concrete, now so on the nose. This process has even gone as far, most recently, as using techniques for suspending glass cladding that are directly inspired by aeronautical construction, to reinforce, further and further, the impression of lightness, of weightlessness, of a massive building wildly trying to be not so much real as virtual – a perfect illustration, if ever there was one, of the revival of illuminism mentioned above.

But one of the apotheoses of the progress in excess in the art of building is currently represented by a newly unveiled bridge – more exactly, a viaduct. A far cry from the 1884 wrought-iron bridge designed by Gustave Eiffel in France's Garabit Valley, Norman Foster's Millau Viaduct is a 'cult object', as the lay republican press calls it. A work of art with its deck standing nearly 300 metres above the Tarn and with a roadway 2,500 metres long, this 'static vehicle' has allowed the anticipated 25,000 motor vehicles a day over it since summer 2005.

The most revealing aspect of this gamble is the determination to be part of the tradition of the long-term commercial operation: 120 years for the Garabit viaduct, 115 years for the same Gustave Eiffel's tower; the lifetime of the Millau Viaduct as a revenue-generator for the Eiffage Group, the company that built the viaduct and now collects the toll on it under government contract, is a mere 75 years, but the main novelty of the deal brokered is that Eiffage will turn the bridge over to the state in 120 years if the

concession proves highly profitable – only, in the same condition as when it first opened . . .

In order to guarantee the hundred-year-plus durability of the edifice, taking into account the flexibility of the components of the 'cable-stayed bridge', 200 electronic sensors have been placed along the complete set of the viaduct's points of resistance (piers, road deck, cable stays . . .).

As one of the directors of Eiffage put it: 'It's rare to see a motorway project with so many instruments.'[4]

These sensors, designed to record the vibrations and pressures resulting from vehicular traffic as well as atmospheric conditions, also allow the structure's temperature to be taken. These data, which are part of the building's health checkup, are endlessly analysed by an electronic control unit permanently installed in the viaduct's toll plaza. On top of this, eighteen video cameras automatically detect any traffic incidents and permanently alert the traffic-monitoring unit.

After the emblematic disaster that occurred in the United States in the last century when the Tacoma suspension bridge was destroyed by the resonance effect of a hurricane, the Millau work has been tested for its resistance to squalls of up to 250 kilometres an hour, translucent windbreaks three metres high allowing the impact of excessive squalls to be cut by half, it would seem, and this, 'without spoiling the bridge's transparency'.

Another record, after record altitude, the viaduct is the fastest ever built, taking only three years to be thrown up . . . Record altitude, record speed: if we were talking about a supersonic jet, such a performance would be easier to understand! But just listen to the architect: 'At Millau, you see the bridge particularly against the sky. We chose light-coloured cable stays to get that transparent effect. The cables disappear and all that's left are the piers and the road deck: these seven upright needles and this thread that runs through them, it's like the viaduct dematerializes.'[5]

After the aesthetics of disappearance of cinema, the time is now upon us of the aesthetics of disappearance of real-estate 'architectonics'. But the principal challenge for Norman Foster's construction site is the use of steel for the bridge's road deck. On this score, listen to the architect when confronted by the engineers: 'While we were studying the two options of concrete and metal for the deck, we had in mind that the steel solution would produce a finer and lighter deck that would allow us to use fewer cable stays to support it.'

'Less is more', the architect Mies van der Rohe claimed – a long time ago, it is true.

After having reduced the duration of the construction site and the number of piers, it was the thickness of the deck that then had to be further reduced to nothing, that is to say, to a thread: 4.5 metres thick for the support base, a few centimetres for the asphalt covering the roadway and a few millimetres, they say, for the steel plate of the framework!

All that just so this bridging pipeline of a structure 'pops up out of the landscape as delicate as a butterfly',[6] with a slimness that gives it such a light silhouette, a silhouette so light and so distant, so remote from the robustnesss of the Pont du Gard, so heavy, so ugly.

But this latest outlandish bout of all-out progress risks itself being overtaken by the bridge over the Straits of Messina, destined to link Sicily with Italy. A cable-stay suspension bridge, also, but one with a single span of over 3 kilometres, which Silvio Berlusconi's government was planning to open in 2006.

Over 60 metres wide, as opposed to the 32 metres of the Millau Viaduct, the road deck of this Homeric bridge – which is capable, they say, of resisting the frequent 200-kilometre-an-hour winds that blow there as well as earthquakes below 7.2 on the Richter Scale – is supposed to comprise or carry, who knows which, 'six parallel laneways and two railway lines on a roadway all in one piece whose oscillation may, in a storm, attain six metres.'[7]

After the vogue in tunnels under the sea, even under the Atlantic Ocean, 'very big bridges' and 'very tall towers' are now all the rage . . .

In Asia, for example, the world's tallest building, in Taipei, is over 500 metres tall; top-level scientists have been wheeled in to assess the borderline state of the structure in question, meaning the limit beyond which the tower would suffer damage if it went any higher; the objective being to be able to calculate the safety factors that need to be built in to resist disasters and to achieve a clear 'probability of negligible ruin'. For 'negligible' read 'acceptable'.

An agreed sacrifice, as we were saying, of the progress in excess . . . Agreed or, perhaps, imposed by the craze in gigantism that is part and parcel of the megalomania contemporary with globalization.

In a court of last resort, who is the 'savant' who today decides what is negligible in a public catastrophe? Which court rules, in all conscience, on the scale of a predictable disaster and on those responsible for such a 'calculation of probability'?

After the event, there is certainly a judgement handed down to apportion responsibility in a calamity but, before the event, there are only research departments and design offices and the guarantee of certified expertise.

For all that, an accident is still not a 'white-collar crime', nor is responsibility the same as avowed culpability. We all know that you can't accuse the future but only the lack of mastery of a work, a work of art that is often nothing more than an extravagant trial run.

To resist or to submit to the fallout from progress? That is indeed the question posed in the age of an accelerated internationalization that no longer treats its 'advances' with any critical distance whatsoever.

Indeed, as one humorist put it, 'anyone who thinks indefinite growth is possible in a finite world is either a madman or an economist.'

To further illustrate this Babelian immoderation, if further illustration were needed, we might point to the fact that there are architecture studios currently assessing towers 800 metres high and that, in Japan, there are people already working on a project 2,000 metres high.

This is it, the art of building as far as the eye can see, where the 'never-ending tower' is never anything more than the clinical symptom of blindness.

Architecture, sculpture, painting . . . art is scarcely anything more now than one state of matter among others – matter that everyone is hell bent on deconstructing, dissolving or disintegrating to the point where materialism looks for all the world like nihilism. And so, after the bitter failure of the 'historical materialism' peddled by the revolutionaries of last century, the elimination of materialism itself is jinnying up as the twenty-first century gets under way. After nuclear disintegration of the kernel of the nucleus of matter, the latest project will focus on dematerializing the science of materials, taking the notion of physical materiality towards digital abstraction.

Adopting on its own behalf, nearly a century late, the (non-figurative) approach of geometric abstraction so dear to European painters, even though its success was infinitely smaller than the success of American 'Abstract Expressionism', the electronic deconstruction under way is headed for the same dead-end where the 'illuminism of the Lumières' winds up in the obscurantism of a numerological mastery that spurns any substantial materiality as well as any distinction between the different 'realms' (mineral, plant, animal) in a fusion/confusion of forms and figures that is linked to the liquidation of representation of the world.

Gathered together on 14 February 2005 at the Royal Society of London, the world community of physicists looked at the opportunity to reinvent the kilogramme. Why the sudden concern?

'Because a natural property is invariable and can be measured at any point of the globe, whereas the kilogramme is only accessible at the International Bureau of Weights and Measures near Paris', the committee specified.[8]

What could be behind this sudden 'expatriation' of the cylinder of platinum–iridium alloy held in the pavillon de Breteuil except some new and final avatar of the dematerialization of units of measure?

A total of seven measures form the basis of an international system of weights and measures: the metre (length), the kilogramme (mass), the second (time), the ampere (electric current), the kelvin (thermodynamic temperature), the mole (quantity of matter) and the candela (quantity of light intensity). Now, only one of these measures, the kilogramme, is still calibrated using a physical object, the famous cylinder held at Sèvres, the other six now being based on unchanging natural phenomena.

For example, the standard metre of the same metal as our standard kilogramme was replaced, in a concern for efficiency, and redefined as the distance light travels in a vacuum during one 299,792,458th of a second. As for the second, it is based on the frequency of the natural vibrations of the caesium atom. Once again, an object is replaced by a trajectory and 'metrology' all of a sudden turns into a 'dromology'!

Imperceptibly, what is wiped out here, in this 'expatriation' of standards, doubled by their 'dematerialization', is the geometry of objective forms, which yields before a trajectography in which radiations and frequencies replace the radius of the circumference, just as the speed of light of photons succeeds the rays of the sun and the shadows cast on sundial walls.

If we do not recognize here manifest proof that the aesthetics of disappearance has definitively supplanted the aesthetics of objective appearance, then blindness is at an all-time high and a panic-induced shake-up of knowledge is just around the corner, lying in wait for us!

This is it, the crisis in visual representation, in these 'primary arts' whereby exposure to radiation deters us from tactuality and physical contact, favouring instead some kind of POSTOBJECTIVE perception or, more exactly, to risk a neologism: TRAJECTIVE perception.

It is easy to see that the geometric or lyrical abstraction of contemporary art is here outstripped by the unexpected development of a DROMOSCOPY in which our view of the world is progressively annihilated.

But let's get back to the standardization of units of measure and, more precisely, to the new measure of the weight of the kilogramme. If the principle of the definitive abandonment of the platinum cylinder is now established, it remains to be decided what natural property will replace it. Two hypotheses stand: 'One requires us to calculate the number of atoms in an object weighing a kilogramme, which will give us a figure of around 10 to

the power of 25. As for the other, it consists in calculating the electromagnetic force necessary to balance a kilogramme with earth's gravity.'[9]

Our savants are to replace, in this fashion, the scales of justice with the calculator, and the analogy of the standard object with the digitization of an extreme precision computer calculation, the very last standard object remaining, nonetheless, the Earth and its weightiness!

'Freeing the kilogramme from the evanescence of matter in order to tie it to the laws of a nature that does not lie, science hopes to further improve the precision of electric measures'[10] – only, this time, we should note, by reference to the specific gravity of an Earth that does not move!

And so the forms of geometry are now to be seen as archaic, primitive and, why not, 'Barbaric', in a sort of metrological Darwinism in which the image of the object is to give way to a calculated trajectory more suited to preserving the measure of all things than was, once upon a time, the counterweight of the weight of the pendulum wheel.

Resistance or submission to the so-called 'liberation of the masses'? In other words, to the evanescence of the material forms the concrete object takes, number replacing mass and the weighing of those cumbersome objects in situ, so necessarily localizable and as heavy to move around as they are, while the trajectories of whatever kind of radiation are available everywhere at once, anywhere, anytime – although not anyhow, as you need a sophisticated instrument to measure them.

'To know is to love', they say. Well, while I may know the weight in my arms of the one I love, I do not measure the electromagnetic force necessary to balance her and I do not calculate, either, the 'atomic number', or nuclear charge, of the magnetism of her body, however attractive it may be!

It is a strange numerological drift to take for a practical area of knowledge that reverts to the abstraction of a 'mathematical ideality' in which, little by little, all that is material and carnal in what surrounds us is abandoned. This distancing, this 'progressive' removal is now nothing more than a loss of vision, not so much telescopic, as yesterday, as endoscopic. And it will end, one of these days, in the profanation of the 'experimental sciences' themselves – as we saw, looking on helplessly, last century, with the emergence of a profaned art that was a cheap substitute for the sacred art reviled by the advocates of historical materialism.

After the accident in substances, the cult of performance leads us to the accident in knowledge. Indeed, if, by definition, the materialist deconstructs the matter he is analysing to delve ever deeper into its ultimate components,

this imperfect knowledge of means rather than ends will sooner or later achieve his self-destruction.

From spatial analysis to vivisection, from chemical decomposition to the splitting of the atom, the day is coming when the materialist savant no longer deconstructs but destroys, purely and simply, producing the titanic shipwreck of a knowledge once so precious. Which is what happened, in the end, on 16 July 1945, in the desert of New Mexico at the place/in the hamlet known as TRINITY SITE.

If you need convincing, just read Leo Szilard, the atomic physicist and pacifist scientist who contributed to the Manhattan Project: 'There was then no doubt at all in my mind that the world was on the road to ruin.'[11]

Aware of the major risk of a future escalation of terror, in March 1945 Szilard even wrote a letter to President Franklin D. Roosevelt asking that the bomb be demonstrated but not used.

The American President was to disappear in April 1945, before Szilard's letter reached him, and we now know what happened after that, with this endemic proliferation that no one knows how to stop.

Drawing the logical conclusions from the historic tragedy of the militarization of science, after Hiroshima and Nagasaki, Leo Szilard quit nuclear physics and turned to theoretical biology, even declaring, apropos the atomic BIG BANG: 'That's not the kind of physics I like and I even wonder if it is physics.'[12]

Unfortunately, as the third millennium kicks off, such a heretical question no longer poses itself in relation to theoretical physics alone, but every bit as much in relation to the fledgling synthetic biology and, ultimately, to the technosciences contemporary with the accident in Progress.

CHAPTER 3
THE NIGHT OF MUSEUMS

Art is the most beautiful way for man to learn that he has religious feelings.

Federico Fellini

'Even beyond its typically religious expressions, true art has a close affinity with the world of faith, so that, even in situations where culture and the Church are far apart, art remains a kind of bridge to religious experience . . . art is by its nature a kind of appeal to the mystery', wrote Karol Wojtyla in his letter to artists,[1] a timely reminder of the strict correlation between 'sacred art' and 'profane art', at the precise moment when the paradoxical question of a 'profanation', not of the sacred anymore, but of 'profane art' and its free expression was about to come up.

This freedom was subject, throughout the whole of the past century, to the expressionism of terror, of its repeat atrocities, from the First World War and especially after the Second World War. Terrorized, knocked into one of the 'war wounded', art was progressively called upon to exhibit outrageous suffering and calamity, on pain of exclusion from the 'field of horror' of artistic recognition.

To violate and vilify what remained of the rules of art, to degrade the practices of profane art, as profane art previously profaned those of the various sacred arts – such was the objective of a century that was pitiless not only in relation to martyred civilian populations, but in relation to those populations' sensibilities, subject as they were to the precarious balance of a domestic terror, in which contemporary culture was soon to emerge as the simulator of the rape of the crowds.

To achieve an art foreign to art, to emancipate the visual arts, free them from what constitutes them – these are all ways of describing a 'progressive' disappearance of aesthetics, whereby the original predator, like the producer, was finally to make way for the exterminator, the one who liberates by tearing down – not just, say, the column of the Vendôme, which Courbet

once tore down, but now the very bridge suspended between the profane and the sacred.

And so, after the profanation of the crowds by the propagandists of totalitarianism, it seems that the time has come for the (real) time of the profanation of their view of the world – in other words, of their spiritual orientation.

Don't forget the untimely declarations of the masters of the Stalinist era: 'Nature is not a temple but a building site.' A demolition site that especially privileges the real time of immediate history to the detriment of the real space of the temple!

Entymologically, the verb 'to profane' stems from the Latin fanum (temple) and what precedes it, pro (before), whence the term 'profane'.

With the contemporary art of disaster, we are no longer dealing with the mundane nihilism of the monochromatic painting of an Yves Klein or the painting without images that epitomizes abstraction. This time, we are dealing with a culture without memory and without any rules whatever. This art of amnesia is part and parcel of the sudden acceleration of the real and the advent of the (polar) inertia of a world where the synchronisation of sensations freezes every representation (artistic, political, . . .) in a telepresence that owes everything to the transfer-machines of instantaneous communications.

A strange article appeared fairly recently in the 'art market' press in relation to a sale that went through Tajan, the Paris auction house. Headed 'The Middle Ages', this is how it ran: 'The statues of the Middle Ages have long been spurned, being considered simply as religious art.' That observation was offered by a shrewd dealer, who added: 'Medieval sculptures are wrongly seen as religious knick-knacks. The reference to the outmoded side of Catholicism has done some damage.'

Extending such typically enlightened commentary, the article ploughed on: 'In Roman art, the sculptures are fairly coarse and stylised. We have some rather stiff, stocky pieces from this era . . . For a long time likened to religious and therefore ritual works, this statuary, though recently released from purgatory, remains a limited market.'

Faced with such lack of discernment (half a century after Malraux), a person might be forgiven for thinking they were dreaming! . . . African art, Egyptian statuary, what are they? When amateur art-lovers collect Pre-Columbian works of art without wondering about their ritual significance, are they right or wrong?

But let's get back to our temple with its square out front, before it, to a moment when Cioran journeys back to the discovery of the little churches of Sermaise, Etréchy, and Chamarande: 'He left me a list of these little churches and one morning I stumbled across them,' François George clarifies. 'They blended in so humbly with the rural architecture that I could have mistaken them for God's farms.'² Isn't it bad faith for an atheist to admire churches?, asks the man who chose Cioran as a guide.

Certainly, there is naivety in the faith of atheism, especially when the 'lay fundamentalism' of confessors to the one true faith is so rampant, peddled by these disciples of a so-called rationalism that has remained untouched by the acceleration of reality.

Before the temple, then, there was the profane church square, the parvis, but after that, after the choir and the apse, there is nothing anymore and you suddenly run up against the EXTERNALIZATION – OUTSOURCING – OF ART.

To illustrate this disaster, you will recall that wag, the British hoaxer, who recently managed to get into four of the greatest museums in New York on the same day – the Brooklyn Museum, the Metropolitan Museum of Art, the Museum of Modern Art and the Museum of Natural History – and hang his works amidst the masterpieces of contemporary art. Some of them remained there, exposed to public view, for several days . . . Drawing the obvious lesson from his act of piracy, the prankster, a young man named Banksy who uses the moniker Banksymus Maximus, came up with this: 'Obviously, museums pay more attention to what goes out than to what comes in.'

To thereby relativize not only the chef-d'œuvre but the œuvre per se – this has to be the dizzy limit in the axing of art!

But speaking of 'free entries', the operation 'Museum Night', launched in 2005 to attract a public no longer to be seen darkening museum doors, a Minister for Culture declared: 'This is much more than an "open door" operation, it's a bid to win over new audiences and create new reflexes.'³

But what is going on here in such a marketing exercise? Not being able to control the intrinsic quality of artworks, contemporary or otherwise, entering the collections of French museums, the minister, anxious about the drop in attendances, made a last ditch attempt at innovation.

After the 'Spring of Museums' in 1999, which managed to tap a million additional entries, a similar surprise attack was once more needed. Whence the 'free night-time entry' in over 700 museums in France and 400 abroad.

Outstripping the sun museum that was behind Olafur Eliasson's show, The Weather Project, at the Tate Modern London in 2003, the Night Museum was inaugurated in Paris to attract the hordes of the young and the not so young as they emerged from their night clubs; the whole thing being graced with ambient music such as in the Musée Gustave-Moreau, where evening visitors could thrill to the rhythms of Salomé's dance . . .

From seven o'clock at night to one in the morning, on the night of Saturday, 14 May 2005, visitors were able to venture out, feeling their way, by torchlight and candlelight, to catch a glimpse of the artworks on show – sculptures at the Musée Rodin, for example, or paintings at the Louvre, which, we are told, reached its 'saturation point' with the crowd rushing to gawp at the enigmatic Leonardo da Vinci's Mona Lisa.

In certain establishments, curators were actually called upon to act as guides to 'enlighten' viewers as to the nature of the works on show. In another example, the Musée Albert-Marzelle in Marmande put itself an hour ahead to Italian time in order to present its pictures and photographs by lantern light. A choir, also Italian, accompanied the dégustation of Venetian specialities.

'Open at Night': this announcement on the part of neighbouring businesses and drinks stalls now festoons the pediments of the temples of art, those buildings that are now being privatized at a rate of knots, once again in Italy. How long before we see cathedrals open at night so we can gawp at their stained glass windows? After the disaffection with museums, how long before we see the disaffection with places of worship that can then be turned into places of mass lay culture, ones where yesterday's 'socialist realism' will give way to the hyperrealism of an art market whose by-products will finally shunt aside works of art?

At this very beginning of the third millennium, with telescopic distancing and the remoteness of optical sensations, the TELEOBJECTIVITY of our perception of the world is doubled with a TELESUBJECTIVITY that largely falsifies our relationship with things, with their concrete presence alongside us and, therefore, with their visual representation, thereby achieving what Marcel Duchamp was after in relation to the urgency of an extra-retinal art.

This is why we better understand, today, the survival of haptic sensations – such as the success of, say, Richard Serra's sculpture, or all those famous 'installations' – in other words of all that is palpable and tangible.

But, behind the OBSCURANTISM involved in the over-exposure and inflation of instrumental imagery, how can we fail to sense the coming CRASH, a crash that will this time involve mental imagery, of an art precisely

of the kind da Vinci warned us was well and truly COSA MENTALE, a mental matter?

At a time when the 'esoteric' interpretation of the Florentine's œuvre has obtained the commercial success we are all familiar with, it is impossible not to flag the scope of a disappearance that now outstrips all aesthetic discernment.

In May 2005, Scott Lash, the director of the cultural studies programme at the University of London's Goldsmith College, organized a two-day conference on the theme. The title of the conference was NEUROAESTHETICS. Olafur Eliasson, Joseph Kosuth, Brian Massumi and Marcos Novak were the leading lights taking part.

'Neuroaesthetics' is another name for a disappearance of aesthetics . . . Unless, this time, we are dealing with the appearance of an aesthetics of neurasthenia?

Indeed, after the mournful distancing of the objectivity de visu and in situ of domestic telescopes and the incessant overflying of the different (aero- or astro-nautical) 'atmospheric machines', this time it is the subjectivity of our relationship to the real that beats a retreat in a panic-stricken movement that lands us in this debacle of an art outside the support-surface of our sensations.

This exotic situation was foreshadowed, it is true, by 'Impressionism' and its pictorial relativity, which kicked off the discreet discrediting of all phenomenology.

In this sense, and in this sense only, LAND ART was to have been, in the twentieth century, the key moment of contemporary art, the very last act before the artist once and for all abandoned the subject, not to go back to the studio but to enter the laboratory.

An involuntary tribute, not to the landscapes of 'classical landscape painting' anymore, but to the common ground, to its desert of terrestrial fullness, before it is totally lost to view, in this OUTLAND ART of a twenty-first century that is now just the century of the finiteness of a planet hanging in the electronic ether, frozen in the inertia of a Real Time that lords it over the extension of territories on all sides.

And so, following art for art's sake and the integral accident, is the time upon us of an art foreign to art – to the profane as much as to the sacred?

An out-of-frame, off-screen art, or more exactly, a tilt-up, in which the virtual would win out hands down against the actual in the acceleration, not of some headlong rush now, as in the days of the avant gardes but, this time, of a rush to the zenith; a fall upwards in a perspective without perspective:

that of an optically correct tyranny in which the synchronisation of multiple presence (telepresence) will outstrip all representation (aesthetic or political) in a sort of sideration of sensations not unlike that produced by narcotics.

According to the Talmud, 'a man who has no ground beneath his feet is not a man'. What can you say today of this 'earthling', of this upward parachutist, in the age of deterritorialization and relocation and expatriation, also known as EXTERNALIZATION – OUTSOURCING – if not that the situation concerns each and every one of us?

HUMAN or EARTHLING? That is the question posed by an art contemporary with the end, with the finiteness of the star that saw the birth of human beings from its humus . . . A question addressed to art as well as to the politics of nations.

In the wake of the Soviets, who were so keen on demolition sites, here is what a Pole (Karol Wojtyla – Pope John Paul II) has to say: 'Nature is a book that man must read and not get dirty . . .' A German, this time, an iconic artist, has typified the status of art as a 'victim of war': Joseph Beuys.

A Luftwaffe pilot, brought down in 1943 and saved in extremis by a gang of Tartars, those territorials who allowed the man to survive in aeronautical weightlessness, the flying artist was not identified as such, but simply as an enemy to be saved in spite of everything. As you will note, yet again, when it comes to the twentieth century, it is impossible to talk about art without talking about flight, ascent – from Beuys to Turrell via a whole host of other artists.

An inveterate theorist of the 'broader concept of art', the aviator who metamorphosed into an avant-garde artist illustrates to perfection the 'obesity' or, more precisely, the dromospheric expansion of Western culture after the total war and its aerial atrocities.

But, note once again, if the landscape painting of the Classical age gave rise, with 'seascapes', to the hydrospheric landscapes that were to inspire nascent Impressionism, the atmospheric landscape of clouds that the art of flying revealed has scarcely left a trace on the history of art, despite the Futurists' attempts at aerialization. After Tatlin, we had to wait till the twentieth century reached the halfway mark before we saw the sphere of influence of an art without gravity expand with Pollock . . . This dromosphere of an acceleration of reality that would lose sight of the point and the line as well as the surface of the ground, despite the return to the desert of the American LAND ARTISTS.

But in terms of a 'broader concept of art' as championed by our bomber pilot, Beuys, we had to wait further still for the expansion of mass culture to

finally see the advent, after the megalomania of total art and the blindness of extra-retinal art, of the megaloscopy of 'art as far as the eye can see' that was to lead to the distancing of immediate sensations and end, finally, in a teleobjectivity more populist than popular, within the very latest COMMUNISM, where the old community of interest gives way to an instantaneous community of emotion, and where 'mass individualism' takes over in turn from the collectivism of totalitarian regimes.

And so, after the œuvre sans figure and the painting sans image, the time had come for the artist sans œuvre, 'conceptual art' leading, after abstraction, to abstention pure and simple; the blank vote of the monochromatism of an Yves Klein yielding its pictorial parody to the theatrical 'living spectacle' of an author without any authority whatever, except that of exposing himself to the eyes of all, of exhibiting his name or his initials (just like a logo). This is a subliminal form of self-portrait, in which obscenity no longer solely involves sexual or scatalogical exposure but is practised on the profane avant-scene, front of stage, that proscenium where the narrator moves forward to meet the audience and alert them as to what is happening on stage, thereby denouncing its 'sacred' dimension.

Notice how, here, the desertion of the producer deprived of an œuvre is accompanied by the title role of 'public informer', of denouncer of what ought to be condemned without any possible protest, on pain of alienating the free expression of the 'presenter', that anchor of disapproval of the sacred as of the profane . . .

Here we see, once more, all the outrageous excesses of the tribune, transferred to the realm of the visual arts as well as to the realm of the arts of the stage. Whence the success of the street arts of so-called urban culture. But there remains the dread of a forced acquiescence, under threat of expulsion, not of the œuvre, now, as in the age of the auto-da-fé, but of its spectator, deprived not only of an authentic representation (theatrical, pictorial . . .) but of his or her free will; the appreciation or depreciation involved in the old Quarrel of the Ancients and the Moderns now giving way to the obligation of a duty of confidentiality before the freeing up of the rules of art.

The faith of sacred art and the talent of profane art are then overtaken by the categorical imperative of a 'mentor' freed from the weight of the manifest artwork, but having in hand the 'Tables of the Law' of a freedom of expression sans free refereeing, in which that other quarrel, the one between the iconophiles and the icono-phobes, in turn disappears before the abstention of the conceptual artist. This is a veritable Kafka trial in which the art

lover is now a mere accomplice obligé, the 'stooge' in a charlatanism that no longer even speaks its name.

But let's go back to this communism of public emotion that has recently, so discreetly, replaced the communism of public interest.

Launched at the beginning of the twenty-first century, the Corporate Storytelling of the Anglo-Saxon world aims at reorganizing history and its tales in politically correct fashion, in order to shape social behaviours – along the lines of the new management, with its spin doctor magician, the accredited astrologer of the business of globalization of public emotion indispensable to the single market. This customized, 'results-oriented' communications 'system' now replaces, in so doing, the 'International Proletariat' of the ex-Soviet Empire, using a welter of media conditioning techniques borrowed from contemporary culture to promote opinion transfers in a pseudo-democratization of emotion that has taken over from the democratization of public opinion that was once the province of the representative assemblies of yore.

And we won't understand anything about the crisis the European Union is undergoing or the refutation of the Judeo-Christian origins of the Old Continent's history unless we come to grips with this hijacking worthy of storytelling that so many lay intellectuals collude in – while so rightly assigning themselves the task of denouncing negationism . . .

In 1932, in a letter addressed to Albert Einstein, Sigmund Freud recognized that, since time immemorial, humanity has been subject to cultural evolution and that we owe the best of ourselves to this phenomenon – as well as a large part of what we suffer. 'The psychic transformations that accompany the phenomenon of culture', he wrote, 'are obvious and indubitable . . . Sensations which, for our ancestors, were charged with pleasure, have become indifferent to us and even intolerable.'[4]

It is in this perspective that we might consider, today, the damage done to an art that is a victim of total war and that is gearing up to suffer the disaster of mass telesubjectivity that some people present as the height of social communication.

Concluding his letter to the man who was shortly to contribute to the launch of the Manhattan Project, Freud warned: 'It does seem that the aesthetic degradations that war entails count no less in our outrage than the atrocities war gives rise to.'

German Expressionism, Dadaism, Surrealism, Viennese Actionism are all so many confirmations of Freud's analysis. He concludes: 'We are not yet familiar with the idea that cultural evolution might be an

organic phenomenon, of the same order as the domestication of certain animal species.'

Since those days, after the camps, and, more recently, after the information revolution, this familiarity with the domestication of the public has become patently obvious – to the point where the phenomenology of perception DE VISU is reversed, thanks to the teleobjectivity of a view of the world that has taken us from the collectivism of bygone days to mass individualism.

In fact, and as we pointed out earlier, our contemporaries no longer want to see but only to be seen by all the tools of audiovisual televoyance.

This is it, the reversal of the scopic impulse of voyeurism, along with the boom in transfiguration, a lay version, now, but one that owes everything to the illuminism of the real time of an instantaneity likely to inspire, tomorrow or the day after, the revelation of a myth of transappearance in which exhibitionism will achieve its goal, promoting not only the synchronization of sensations but, especially, the globalization of affects.

A perverse situation in which the 'communism of public emotion' will be redefined à la Lenin: 'Revolution is communism plus electricity.' To adapt this to current tastes, all we have to do is replace 'electricity' with 'electronics'.

Strangely, and as though to confirm this transfer of the voyeur to the congenitally blind, of which Ray Charles was a sublime example, after the sunglasses and the balaclavas and the hoods, we are seeing today the burying of ocular perception behind pseudo-masks.

As further proof of this observation, we are also seeing linguistic violence and even crimes committed as payback for 'dirty looks'. This has reached the point where, in certain residential estates, some people, and not only young women, walk with their eyes riveted to the ground in order to avoid any aggression.

At a time when walls are everywhere and borders nowhere, this fencing-in not only contributes to erecting tomorrow's CLAUSTROPOLIS. It especially contributes to suppressing perception of our surroundings, because faces are not the only things veiled now, as a short while ago. The visual field, too, is shrinking badly, illustrating by this fact the topological or, more accurately, TOPOSCOPIC about-face evoked above, for, instead of projecting ourselves into the distance and all around us, we keep our eyes down to look only at our toes in what is not even timidity any more but a form of introversion. In this forced perspective, our vision of our immediate environment is no longer anything more than guilty introspection, capable tomorrow of ending in a public confession, at the express behest not of some

political commissioner any more, but of the public presenter, the disc-jockey of 'urban' culture . . .

Significantly, what we are seeing in 'musical pop culture' circles, following deployment of the hood, is the use of various masks by singers and musicians in bands performing live on stage.

Once there was the balaclava of the kamikaze, then there was the more-or-less monstrous mask or, going even further, the video headset of virtual reality. Now, what is emerging with the barricading of the artist behind his instruments is his pure and simple blindness.[5]

One such musician puts it in these terms: 'On stage, make-up helps us focus exclusively on the music, on getting out of ourselves.' In other words, on getting into ex-tacy. Here the mask is no longer a carnival disguise, but 'a safety-valve behind which you can do violence and do violence to yourself'.[6]

All is said, nothing is seen, since the mask rules out all identification and puts paid to the notions of authenticity and embodiment that still characterized the rock era.

Robot mask or death's head, it is no longer work that makes you free here, it is anonymity that promotes licence. From now on, contrary to what Paul Klee claimed, art no longer makes visible but blinds. As for the mass culture of the century of audiovisual illuminism, it makes you deaf and dumb in the face of any heretical opposition to its conformism.

Let's now go back to the TOPOSCOPIC reversal stemming from the acceleration of the real, as the third millennium gets under way, with an endless round of satellites observing and monitoring, point by point, the surface area of a globe where earthlings have come to no longer look at anything, beyond their screens, but the ground, the surface that supports them.

Dispossessed of the horizon, of its line and its vanishing point, the erstwhile observer suddenly turns their ocular perception inward and limits their gaze to the 'support-surface' of ordinary everyday territory, even while their long-distance vision is transferred, no longer to the antique field-glass, but to the innumerable television channels and sundry WEBCAMS that illuminate their abode more intensely than electric lighting can possibly do.

Very recently, home delivery of blockbuster images designed to appeal to a wide audience has been paired with the televisiophony by means of which the insupportable portable, in tandem with voice mail, allows you to see and especially to be seen by your interlocutor. This third-generation mobile telephone still further distracts the attention of those circulating, at the risk

of causing the kind of accidents that result not so much from loss of control of a vehicle as from the driver's inattention.

In Frankfurt, certain cinemas have recently found a remedy for employees' stress: they offer cinema sessions SANS FILM, so that everyone can relax before getting back to work. At 3 euros for a thirty minute session and with soft background music, the concept is all the rage throughout Germany, with ninety cinemas already offering the service.

After Guy Debord's film sans image of 1952, this new 'service' means attacking the author of The Society of the Spectacle from the rear since, if we follow this concept in vogue on the other side of the Rhine (and the other side of film) to its logical conclusion, the general strike could soon become the very latest public service . . .

Here again, procedural inversion, topo-scopic reversal of the situation, the turnaround distinguish themselves by withholding, by lack. Alongside the sunglasses and hoods in vogue in the suburbs, the darkroom is now actually reviving, for a harassed collectivity, the balaclava of idle individuality.

Not only do you no longer look up at the firmament to gaze at the stars. You no longer even look at the screen. The latest screening is a doze, a siesta, in a room SANS SPECTACLE, which would be to the 'public transport' that films are what the waiting room already was to the railway station in the days of the Lumière Brothers . . .

After the strike by people employed intermittently in the performing arts, we now have the intermittence of movie theatres, freshly morphed into 'altars of repose' of unemployment, or, more aptly, day centres taking in the vagrants of idleness . . .

But that's enough of these out-of-date considerations. Let's get back to the toposcopic reversal that characterizes the twenty-first century. Following the telescopic hijacking of astronomy, along with domestic television, we are thus seeing the beginnings of another hijacking, this one 'endoscopic', revealing the closing in of the terrestrial globe, where the ultimate vanishing point is now to be the centre of the Earth: this kernel where the real space of geopolitical extension has just ended (or more exactly crashed), literally becoming confused with the centre of time, of this real time without localization other than the axis of gravity that still resists the chronopolitical instantaneity of the globalization under way, in a TEMPORAL COMPRESSION with more serious consequences for human beings than those resulting from the shifting tectonic plates of our tiny telluric planet.

In fact, what is profaned with this reversal of perspective is the concrete orientation of our 'view of the world'; of a world once panoramic, open to

the infinitely big, which, thanks to acceleration of reality, suddenly becomes the hypercentre of interactivity, to the detriment of a universal exteriority delivered up to the lack of localization, to the loss of any true position (ethical, political . . .), where the thin habitable film of geophysical expanse is internalized, literally locked up at the centre of the 'world time' of immediacy and its panoptical ubiquity.

This is it, this about-face, not so much topological as toposcopical, this absolute here of carceral entropathy, this zero degree of the freedom of movement of a world that has turned INFRAMUNDANE.

It is right here, the hidden problem of the pollution of distances that finishes off the pollution of substances belonging to the old ecology, this 'integral accident' of the profanation not only of nature but of its size, its LIFE-SIZE GRANDEUR.

On this point, let's hear it from Edmund Husserl once more:

> We also need to study the relationship between optical space and haptic space, the extent to which a grounded corporeity necessarily constitutes itself in optical space, on the one hand, and, on the other, in haptic space; and finally, the extent to which it necessarily constitutes itself according to the proper meaning of corporeity and by asking ourselves further what is the place of the necessary constitution of the flesh? Terrestrial ground, walking, resistance, praxis, collision and production of effects at a distance.[7]

How can we inhabit a nature now without grandeur? How situate one's body of flesh, one's language and one's art, in a voyage to the centre of the Earth that owes nothing to Jules Verne, for it does not require any physical displacement (subterranean or otherwise), nor any voyage in space, this CENTRE never being anything other than the centre of time, of the 'real time' of a depth without density?

In the standstill of this meta-geophysical on-the-spot motion, and thanks to the egocentricity of the living-present studied by Husserl at the end of his life: *the centre of the Earth is me*! Nothing but me, and no longer us, mass individualism never being anything but the (forbidden) fruit of a finite world revolving around the egotism of the 'living-present' of each and every one of us. This present directly (live, life, . . .) reflects the real time of a media-generated immediacy that takes over, by deception, from the only-too-real space of bodies and their age-old freedom of movement in the geophysical expanse of a human habitat now returned to its original inertia.

By way of confirmation of this hypercentration of contemporary individualism, let's now look at the supposedly eccentric lifestyles of those who can do anything, or very nearly.

Leaving behind Bill Gates and his dwelling of over 6,000 square metres, from where the Corbis magnate can call up, at every instant, displays of the works of the museums of the entire world on the multiple screens that decorate the walls of his rooms, let's now contemplate the villa of the actor, John Travolta. This villa is situated at the centre of a private airport that has two landing strips and overhead walkways providing a direct link between the building's living rooms (on the hiking tour) and the cabins of Travolta's Boeing 737, stage right overlooking the garden and his business jet, stage left, the two vehicles, big and small, of the ambulatory dwelling that each comprise the 'spare parts', no longer of a dwelling in which to stay, but of a sort of 'control tower' from which to leave, to exit – exclusively upwards, not at ground level, the garages being nothing more now than sheds storing collector cars.

A name springs to mind for this type of twentieth-century 'folly' that replaces the old home-sweet-home: an EXIT-HOUSE. For in it the place of ejection takes over from the places of predilection of the communal city.

Between the teleobjectivity of the man who transforms his dwelling into a VIDEO POST-PRODUCTION UNIT and the aeromobility of this master of the house cum captain of an ambulatory residence, MEGALOSCOPY has reached an alltime high. Alongside the multiple screens of the control room that display images of the world – what no one dares yet call his 'instrument panel' – as on board this control tower for private jets, each man is not only on the edge of the terrestrial globe but at its brink, in this delirium that Howard Hughes prefigured before winding up bedridden at the top of the tower of the Desert Inn in Las Vegas and then dying in flight, on board a flying doctor aeroplane.

Strangely, too, a connection can be made between these exercises in an ambulatory madness (dromomania) and those of the relocation involved in political or security internments – that diaspora of the American concentration camps.

In fact, following the outsourcing of torture chambers to the four corners of the globe, we now have the exotic relocation of an abomination, this one furtive, since it seems the legal system can't detect it, for it not only sets itself up above the law (as the president of the Red Cross cautioned) but above the ground, in weightless suspension in 'secret planes' chartered by the CIA, such as the Boeing 737 and the Gulf Stream Turbot used for transferring detainees suspected of terrorism and held illegally.

In response to these unpleasant practices, listen to St Augustine: 'The mistake the soul makes about itself stems from identifying with such images so lovingly and intimately that it ends up judging itself as some like thing. It becomes absorbed in such images, not through this being but through thinking it is: it is not that it imagines itself to be an image, but it imagines itself to be that which it carries the image of inside itself. For the power to judge subsists in the soul and causes it to distinguish the body that remains external to it from the image that it carries inside it – unless these images are externalized to the point of being taken for the sensations of foreign bodies rather than internal representations. This regularly happens in sleep, in madness or in certain trances.'[8]

But, speaking of transport, of transport to the brain, the final stage of such madness is today achieved by the ultimate pantheist idolatry: identification of the human being's body proper with the earthling's world proper.

In this individualist delirium, I am the whole world, I am the one who is, the one who was, and the one who will be! A fatal demiurgic conclusion whereby humanity, totally confused with the humus of our origins, no longer even distinguishes the expanse of the geophysical environment from its own physiology, in a sort of cult of personality that strikes, this time, not only the tyrant, but the common run of mortals – in other words: each and every one of us.

In a documentary essay on 'superstition', Serge Margel signals the surge not only in sectarian, esoteric and related practices but in the individual religions to come, that will emerge from the ruins of symbolic power: 'As soon as society is limited in its symbolic power, superstition becomes inevitable and, therefore, necessary as a compensation for the disequilibrium that constitutes it . . . and this is when civil lay society will find this specific type of equilibrium in personal religions that the individual establishes by himself and for himself.'

Pursuing this report of the bankruptcy of the political that betrays the body-proper's practices of INTROPATHIC fusion with the world-proper of physical finiteness, the author writes:

To rethink here the individual, the unique, the singular, above and beyond any opposition between 'individualism' and 'collectivism', means reconsidering the individual in their limit or limited state. No longer at the limit but as themselves limit of the impossible symbolic representation of society. And so, as limit of society and nation – but also of generation, tradition, soil and blood.

Margel concludes: 'The individual here is the setting up of the landless, meaning not only those who no longer have any land, but the one who will never again have land, never again have flesh and blood, their own flesh and blood. Individual religions on the outer edges of the Earth.'[9]

Curiously, this terminal approach to beliefs and creeds makes no reference to megalomania, to the disaster that has befallen the political assembly and the ecclesia. But, conversely, it introduces the catastrophic possibility of a new form of 'civil war', which would no longer be the not-so-distant war of each against all, but the suicidal war of each against each. Let's go to the very last lines of Serge Margel's book:

> A new temple for a new world. New conflicts, too, new outbreaks of violence and new forms of tolerance which we will have to think differently. What also looms in the appeal of new religions is a war of the landless for a world to come, based on 'better promises'. In brief, new wars of religion are gearing up . . . This will no longer mean war between institutions or on behalf of an institution. It will mean religion sets itself up as war.[10]

What Margel is describing, in a way, is the civil war of a MONOTHEISM in which 'the unique and its property' take themselves for the completely other, all on their own!

Megalomania or megaloscopy? We can well imagine that this fanatical demiurgy of mass individualism conditions not only the political event of atheism, but the whole of culture – that 'view of the world' that is inseparable from the issue of God and thus of all religiosity, individual or collective.

The quarrel over images of the iconoclasts then turns into a quarrel over the VISIBLE and the INVISIBLE; a quarrel not only about the OBJECT, pictorial or otherwise, and the SUBJECT, but about the TRAJECTORY without delay that goes so far as erasing the very memory of the 'mental map', the mental mapping that once allowed us still to get our bearings, to stand up to the other as well as the completely other.

Strangely, when it comes to superstition and magic, Margel's essay doesn't tackle multimedia power and its teleobjective creed, or social conditioning and its interactive feats, or the emotional synchronization that results from it today – on a planet-spanning scale.

All the same, all the same, how can we treat superstition seriously without tackling the emergence of public opinion?

Even if the word 'public' makes reference to the res publica and even if private faith relates to the ecclesia, public opinion is no more foreign to faith and beliefs in a radiant future than emotion is to reason.

Also, apropos the visibility now at issue in the religious as well as the political order, let's not forget that the sight of a path, the line of sight, that allows man to attain his target, used to go by the name, in French at least, of 'line of faith', only yesterday, though the term is today censured and replaced by the term 'line of aim' . . .

Superstition or religion? Objectivity or subjectivity? TELEOBJECTIVITY of communications tools or TELESUBJECTIVITY of the audiovisual?

So many questions contemporary with a cultural malaise that does not date from the twentieth century, whatever they say, but from the Age of Enlightenment. But this malaise finds itself singularly exacerbated in the twenty-first century by the emergence, fatal for representative democracy, of this ILLUMINISM of the Last Day that goes by the borrowed name of – real-time – INFORMATION REVOLUTION.

Whether we are dealing with the objectivity of reason or the subjectivity of belief, we will never make head nor tail of this particular revolution without according, at last, the place it deserves to the trajectivity of the waves that carry the messages of the medium; those electromagnetic vibrations that tug at the heartstrings and insidiously collectivize emotions that owe everything to the immediacy and the ubiquity of information flows that cross the virtual space of telecommunications – in 'real time'.

In an important course given at the Collège de France and devoted to the internationalization of law in the age of the necessary governance of the Internet, Mireille Delmas-Marty remarked: 'How can we apply this requirement to digital networks devoid of any management centre and that are NEITHER OBJECTS NOR SUBJECTS OF LAW, but conceived in some sort as A PATH, a trajectory passing first through the access provider, then the host, then the content editor and, finally, the internet user?'[11]

She concluded: 'From financial flows to information flows, the issue is not deregulation, but the appearance of a space that cannot be assimilated into a territory (and so is, in this sense, virtual), that is neither private nor public but simply outside the law.'[12]

This is it, the profanation of 'the art of the possible' of the politics of nations; this is definitely it, this OUTLAND ART that denies representative democracy its inscription in the real space of some soil, and thus its territorial localization; real-time exchange flows further accentuating the difficulty of framing, legally or otherwise, a transnational activity now corrupted into

a sort of (virtual) interactivity that dissolves, one after the other, the spaces of the law as surely as nuclear radiation dissolves those of the body.

By way of conclusion, one question has to be asked: in the wake of the popular democracies formed by totalitarianism's community of interest in Eastern and Asian countries: is the direct democracy of the global age's community of emotion still 'democratic'?

Or is it not, rather, a sort of COMMUNISM of public emotion that cunningly revives that of Marxism, in order to serve the interests of a TURBO-CAPITALISM of real-time exchanges, in a world from now on devoid of the limits and time lags that the geopolitics of nations was still, only yesterday, based on?

Whereas the old community of interests of collectivism was based, for its part, on the ideals of social justice (diverted away from Christianity), the community of emotion of mass individualism is built on the management of fear, of precariousness, thanks to the prowess as well as the promise of immediacy and ubiquity.

In plain language: can democracy be TOTAL and interactive without immediately ceasing to be democratic and truly participatory? This all boils down to asking, though the other way round, the question of the necessary separation of church and state on which republican secularism is based. Can democracy be universal, in other words catholic and cathodic, without being something other than a glitch, the integral accident in politics?

This is surely the reason for today's boom in the transpolitical vulgate peddled by liberalism and, especially, by the ideology of a sovereign interactivity that will end, tomorrow or the day after if we are not careful – just as the interactivity of radioactivity did yesterday – in the overriding necessity for a new kind of DETERRENCE, one no longer military but civil.

This is surely also the reason for this threat of the disappearance of the legitimate state, 'these risks that bring us back to earth, from virtual space to real space, but that apparently distance us from the field of law, for what characterizes them is uncertainty. However, to take uncertainty into account should not lead us to base on fear an ethics that would then wind up blocking scientific research as well as political decisionmaking', Mireille Delmas-Marty goes on to write, adding: 'This is how globalization prompts a worldwide policy of prevention and precaution, whether concerning biotechnological or ecological risks.'[13]

We might add the risks of terrorism to the list and thus infer the need for a strategy of preventive war, such as the Anglo-Americans have led in Iraq, with the success we are familiar with . . .

Taking the uncertainty principle into account in the politics of globalization actually contributes to the introduction, everywhere at once, of preventive action and anticipation of threats, including those that now weigh on representative democracy. And, here, the accident or, more exactly, the catastrophe of contemporary art is prophetic of the major risk of public profanation that now threatens all REPRESENTATION and, in the short term, all 'civilization'.

Before the visible, there is the profane nature of the pre-visible, but, after the visible, all that subsists is the imprévisible – the unpredictable, the unexpected – along with the revelation of the accident in knowledge.

CHAPTER 4
ART AS FAR AS THE EYE CAN SEE

Is an art that endlessly solicits cognitive persistence visual or musical? Is an art that no longer addresses itself so much to the visible as to the audiovisible a graphic art? So many questions that today are without answers, yet determine art criticism.

The moment the whole array of the visual arts is suddenly overexposed to mass communications tools, the question of retinal persistence poses itself in a completely new way, one that puts paid to the now sterile criticism of, say, Marcel Duchamp denouncing the limits of retinal art. While certain filmmakers – like Pip Chodorov – try 'to make the visual cortex undergo what music does to the temporal lobe'[1] and cinematographic imagery becomes, in a way, the backing for music, this is not so much about music turning into IMAGE as about image turning into MUSIC – graphic, photographic image, certainly, but also, equally, the digital array of computer imagery that now tends to supplant the analogic regime of optical imagery.

Wherever the instrumental image of the audiovisible replaces the mental image of the visible, in fact, what comes into play is the coup de force of a so-called TOTAL ART in which the seventh art of cinema, not content to contain all the rest, as Georges Méliès hoped, suddenly opts for a fusion/confusion of genres in an ICODIVERSITY of the perceptible which is the equivalent of the BIODIVERSITY of species, to end in the unicity of a sensation that some people like to think of as a 'visual orgasm',[2] whereas it is actually nothing more than a fatal amputation, the castration of the difference between the five senses that enables us to experience the relief of bodies and their distinct shapes, along with the world's relief.

Photography has never actually been anything more than the first of these 'arts of light' that have little by little contaminated the perceptible through a 'photosensitivity' whose history is yet to be written.

Even though, from the very beginning of photography, the heliographic shot put TIME-LIGHT to work – that is, the limit speed of a luminous radiance – the graphic arts, for their part, enlisted the TIME-MATTER of the sole persistence of a material support (canvas, stone, bronze, . . .)

and, thereby, the aesthetics of the progressive appearance of the figures of the visible.

With the photogram, this resistance of materials came to an end, leaving room only for the cognitive persistence – accordingly known as 'retinal' – that allows for perception of movement and its acceleration, from the cinematograph right up to the recent feats of real-time audiovisual videoscopy. Whence the term art-light for all that now enlists in the aesthetics of disappearance, whether filmic, analogical or digital.

And so, with the audiovisible and especially the turning into music of the image, of all images, sonorous and visual sensations, far from completing each other, are confused in a sort of MAGMA where rhythms hold sway over forms and their limits, swept away as they are in the illusionism of an ART WITHOUT END, without head or tail, where you literally no longer distinguish anything apart from the rhythmological rapture. There is no clever feat of deconstruction here, only the beginnings of pure and simple dematerialization of the art of seeing and of knowing; the confusion of the perceptible that is analogous, in many respects, with the confusion of this Babelian language where everything dissolves into the indistinction, followed shortly by the indifference, then by the passivity, of a befuddled subject.

An obvious point imposes itself here: if seeing and knowing were, until now, the great quests, at once ethical and aesthetic, ever since the eighteenth century with its Enlightenment, seeing and being able have become the great quests of our twenty-first century, with the outstripping of the politically correct by the optically correct – this correction that is no longer the ocular correction of the glass lenses in our spectacles but the societal correction of our view of the world, in the age of planetary globalization.

In effect, if totalitarian societies tried to realize such a panoptic policy, the global society that is looming possesses the audiovisual tools to bring it off completely, thanks to the acceleration of reality of which the art of seeing is perhaps the very first victim.

Here, the issue is thereby no longer only to do with the 'figurative' and the 'non-figurative', as in the twentieth century, but indeed concerns representation in the real space of the artwork and the pure and simple presentation, in real time, of untimely and simultaneous events or accidents that certain artists sometimes call performances or installations . . .

Even while the acceleration of art history, at the beginning of the twentieth century, merely prefaced the imminent ousting of the figure, meaning of all figuration, the acceleration of reality contemporary with our twenty-first century once more undermines all 'representation', not only pictorial or

architectural but especially theatrical, to the detriment of the political stage of representative democracy.

Whether we like it or not, what is today very largely contested by the outrageous excesses of cybernetic progress, as well as of hypersonic acceleration, is the whole set of representations. What are exclusively promoted thereby are these techniques of instantaneous telecommunication of real-time presentation of facts as well as of artworks that were once visual and are now purely 'mediatic'.

All that is still fixed is in fact threatened by this 'panoptic inertia' of the speed of light in a vacuum; of these electromagnetic waves that dematerialize the œuvre using the optical radiance of daylight – exclusively promoting the electrooptical radiance of the false day of screens.

HERE, but where is that, in the end? The graphic sedentariness of the visual arts becomes a defect in the face of the general mobilization of sequences no longer animated as yesterday with the film reel but infinitely accelerated right to the limit of visibility of images (analogue, digital, . . .). And this has reached the point where morphing now outstrips the ancient immemorial morphology of the figures of representation.

In an age when our view of the world has become not so much objective as teleobjective, how can we persist in being? How can we effectively resist the sudden dematerialization of a world where everything is seen, déja vu – already seen – and instantly forgotten?

How can we persist in the real space of the œuvre, while the acceleration of real time sweeps away everything in its path?

On this score, here is Maurice Blanchot: 'Talking and writing are not the same as seeing. Whence my apprehension when I see the written word move to the visible. Even reading out loud is painful to me.'[3]

While retinal persistence furnishes the background necessary to all perception of movement, the same cannot be said for the cognitive persistence of speech and its fleetingness. Whence this unbearable forgetting, when faced with the audiovisual scene of the mass media.

As a man of the theatre explains in relation to a representation where the voice of the actors is given to the variations in stage lighting: 'In times of over-communication, the value of the word is lost.'[4]

Of the word, certainly . . . but what about of art, of its traces as rock painting in this art of design that is inseparable from the designs of the author?

If over-communication is fatal to the dramatic stage, over-exposure is equally fatal to the artistic stage, to its authenticity in a panic-ridden world where the nebula of contemporary art never ceases growing, like the fog of

war; this 'war of images' that will from now on be delivered to us in closed circuit – until the revolving PANORAMA offers us, tomorrow, in real time, if not the end of the world then at least the end of 'the art of seeing'.

'Maybe she died from never having been seen?', wrote Guy Dupré, in 1962, of the death of French novelist, Roger Nimier's girlfriend, who disappeared one night in a car accident that cost both her and Nimier their lives on the highway west of Paris.

Before such nebulosity, in which the violence of colliding images seems the only means of expression, the objective œuvre, for want of some chef d'œuvre, emerges like a phenomenon of resistance.

Through its visual affirmation, in the face of the avalanche of information, it reinstalls the emergency ramp without which no culture is likely to 'last'.

Art-Light in the process of turning into the music of the televised image, or else art-matter of the visual arts – we have to choose. We have to choose between dynamics and its panic, the putting into a trance of the enthralled multitudes, or statics, material resistance and its tectonics of sense as well as shared sensations. It is here, I think, that the fate of political philosophy is today being played out.

Even while the 'nationalism' of days gone by was centripetal, exerting a gravitational pull towards the centre, into its capital, on power and rural populations, the transnationalism of globalization is, for its part, centrifugal, ejecting outwards towards the outside all that was still precisely located, here or there.

And so, the globalization under way acts in the manner of a CENTRIFUGE that outsources any and every (geophysical) implantation and any and every (geopolitical) representation. EXTRA OMNES (everyone out) could well be the slogan of this DROMOSPHERE of the acceleration of reality, where the centre is nowhere and the circumference everywhere at once!

In a prose piece dating from the year 2001, Louis-René des Forêts wrote: 'Thought gravitates around the same haunting theme with so little variation that you would swear it was enthralled by this orbital movement, bewitched by it. Yet it nevertheless persists in the hope that its capacity to break out of the circle and take off will be restored to it . . . the optical error to be avoided being to throw what derives from life at what is its absolute negation – in anticipation of this happening.'[5]

But let's get back to our centrifuge, so useful in training the astronaut to leave the ground. By dint of copping the 'Gs' of the merry-go-round's

acceleration, the fatal moment comes when that human guinea pig suffers what is known as a 'blackout' in which he loses sight and faints . . .

That is where we are at, or almost, in the realm of the culture of sensations. The main sign of this is the extreme infatuation with music to the detriment of the plastic arts, producing this *Stimmungsdemokratie* – democracy of mood – which is taking over currently from the democracy of opinion, where reflection in common once claimed to hold sway over the conditioned reflex.

The very first politics of speed is the art of music, this 'art of the fugue' in which the present, the present instant, dominates tempo and musical rhythms.

So it is only logical that the long duration of contemplation de visu – with our own eyes – is being annihilated, the putting of silence on trial through works exposed to the eyes of all, promoting the emotion of each, at the same moment.

Today, the economy of culture has radically changed nature, since the principle of accumulating major works has been overtaken by the principle of accelerating the display, the turnover of an art in permanent transit.

As for the museum that, nonetheless, constituted the public treasure belonging to the generations to come – it is literally pillaged by the advocates of an audiovisual administration in which the music of the spheres sweeps away, one by one, the voices of silence, just as the voices of the sirens once sent ships and their cargoes to the bottom.

.

NOTES

Chapter 1. Expect the Unexpected

1. Albert Camus, *Actuelles. Ecrits politiques* (Paris: Gallimard, 1950). English edition *Camus at Combat: Writing 1944–1947* (Princeton NJ: Princeton University Press, 2005), ed. Jacqueline Lévi-Valensi, tr. Arthur Gold-hammer (translation modified).

2. Maurice Merleau-Ponty, *Eloge de la philosophie* (Paris: Gallimard, 1953).

3. Camus, op. cit. Camus actually says 'a frightening man' (translator's note).

4. Camus, op. cit.

5. *Courrier international*, February 2005.

6. Cf. Patrick Vauday, *La Peinture de l'image* (Pleins Feux, 2002).

7. Merleau-Ponty, op. cit.

8. Ibid.

9. Advertising copy, 2005.

10. Hans Erich Nossack, Nekyia, *Récit d'un survivant* (Paris: Gallimard, 1955), French tr. D. Naville.

11. Merleau-Ponty, op. cit.

12. Edmund Husserl, *La terre ne se meurt pas* (Paris: Minuit, 1989).

13. Maurice Blanchot, *L'Entretien infini* (Paris: Gallimard, 1969).

14. Guillaume Apollinaire, *Tendre comme le souvenir* (Paris: Gallimard, 2005).

15. Genesis XIX, 17:26.

16. 'La vue par le toucher' in *Sud ouest*, 24 April 2005.

Chapter 2. An Exorbitant Art

1. *Suivez l'artiste*, on Channel France 3 in February 2005.

2. Sylvie Vauclair, *La Chanson du soleil* (Paris: Albin Michel, 2002).

3. Fascist Italy, Nazi Germany and the Soviet Union. Cf. Fritz Thiede and Eugen Schmahe, *Die fliegende Nation* (Berlin: Union Deutsche Verlagsanstalt, 1933).

4. Dominique Buffier, 'Le Viaduc de Millau, l'ouvrage d'art de tous les records', in *Le monde*, 14 December 2004.

Notes

5. Interview with Norman Forster in *Le monde*, 14 December 2004.
6. Ibid.
7. Article by Marcelle Padovani in *Le nouvel observateur*, 6 January 2005.
8. Quoted in an article by Christophe Lucet in *Sud ouest dimanche*, 27 February 2005.
9. Ibid.
10. Ibid.
11. In Nicolas Witkowski, 'Léo Szilard, comment on arrête le progrès', in *Une histoire sentimentale des sciences* (Paris: Le Seuil, 2003).
12. Ibid.

Chapter 3. The Night of Museums

1. *Letter of His Holiness John Paul II to Artists* (Libreria Editrice Vaticana, 1999).
2. François Georges Mathurin Maugarlonne, *A la recontre des disparus* (Paris: Grasset, 2004).
3. Agence France Presse correspondent in *Le Monde*, May 2005 and *Sud ouest*, 12 May 2005.
4. Albert Einstein, Sigmund Freud, *Pourquoi la guerre?* (Paris: Rivages, 2005).
5. 'Chanteurs masqués' in *Chronic'Art*, No. 19, April-May 2005.
6. Ibid.
7. Husserl, op. cit.
8. St Augustine, 'De Trinitate', Book X, Chapter VI: quoted in Serge Margel, *Superstition. L'anthropologie du religieux en terre de chrétienté* (Paris: Galilée, 2005).
9. Margel, ibid.
10. Ibid.
11. Mireille Delmas-Marty, 'Le relatif et l'universel', course and course-work for the Collége de France, published in the college yearbook, 104th year, 2003/4.
12. Ibid.
13. Ibid.

Chapter 4. Art as Far as the Eye Can See

1. Pip Chodorov, quoted by Jennifer Verraes in the revue, *Trafic*, Spring 2004.
2. Chodorov, ibid.

3. Maurice Blanchot, 'Lettre à un jeune cinéaste', 16 August 1986, quoted in *Trafic*, No. 49, Spring 2004.

4. Joël Pommerat on the subject of his play, *Au monde*, a show about speech. Extract from an interview with J.-L. Perrier, in *Le monde*, 9 March 2004.

5. Louis-René des Forêts, *Pas à pas jusqu'au dernier* (Paris: Mercure de France, 2001).

INDEX

Note: This index covers only Part One of this book.

Index

www.ingramcontent.com/pod-product-compliance
Ingram Content Group UK Ltd.
Pitfield, Milton Keynes, MK11 3LW, UK
UKHW020737280225
455688UK00012B/700